PAINTING WITH WATERCOLOR

PAINTING WITH WATERCOLOR
MARIO COOPER

 VAN NOSTRAND REINHOLD COMPANY

NEW YORK CINCINNATI LONDON TORONTO MELBOURNE

First published in paperback in 1981
Copyright © 1971 by Van Nostrand Reinhold Company
Library of Congress Catalog Card Number 72-149253
ISBN 0-442-21509-6

Van Nostrand Reinhold Company
135 West 50th Street, New York, NY 10020

Van Nostrand Reinhold Ltd.
1410 Birchmount Road, Scarborough, Ontario M1P 2E7

Van Nostrand Reinhold Australia Pty. Ltd.
17 Queen Street, Mitcham, Victoria 3132

Van Nostrand Reinhold Company Ltd.
Molly Millars Lane, Wokingham, Berkshire, England RG11 2PY

Cloth edition published 1971 by Van Nostrand Reinhold Company

16 15 14 13 12 11 10 9 8 7 6 5 4 3 2 1

CONTENTS

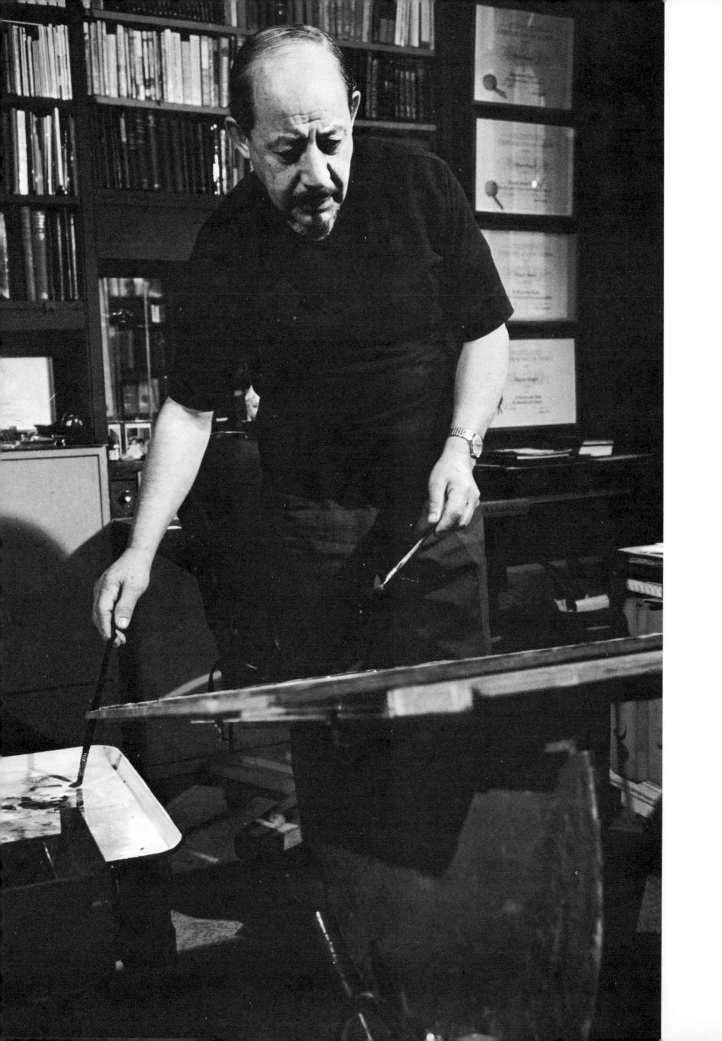

preface

In *Painting with Watercolor*, as in his other books, *Flower Painting in Watercolor* and *Drawing and Painting the City*, noted creative artist Mario Cooper has utilized his talents as a teacher in order to render the most effective and stimulating learning experience possible through the printed page. Integrating print and pictures for a unified graphic design; capturing in writing the distinctive atmosphere surrounding the artist, as well as his techniques and instruction; visually documenting the artist at work and his step-by-step methods through dynamic photographs—these are the important visual and editorial concepts behind Mario Cooper's books. Mario Cooper is an artist who has devoted his talents and energies to mastering the exacting medium of watercolor. In this volume he imparts the knowledge, the wisdom, and above all the devotion that have gone into and resulted from all the years he has been painting with watercolor.

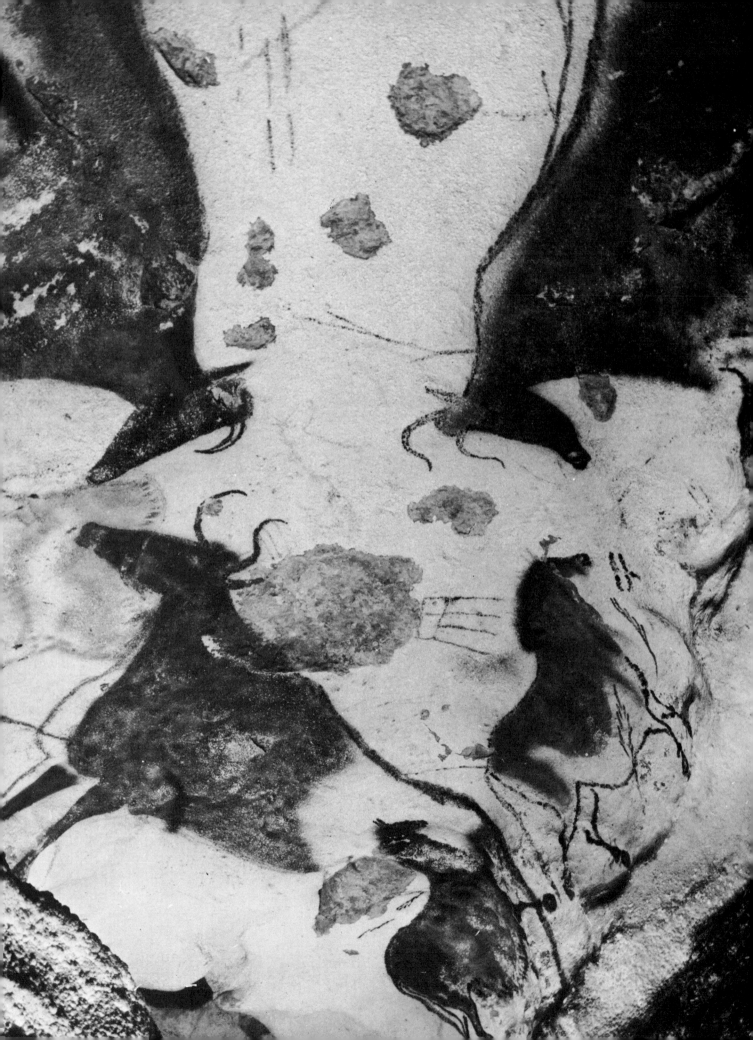

Watercolor is the oldest painting medium known to man. It dates back to the early cavemen who discovered that they could add life to drawings of animals and other figures that they drew on the walls of caves by mixing the natural colors found in the earth with water.

Splendid examples of the caveman's craft can still be viewed in the caves of Lascaux and Font-de-Gaume and Altamira in Spain and France.

Fresco, one of the greatest of all art forms, is watercolor. It is formed by mixing pigments and water and applying them to wet plaster. Most of the thousands of people who stand under Michelangelo's heroic ceiling in the Sistine Chapel are probably unaware that they are seeing perhaps the greatest of all watercolor paintings.

The invention of oil painting by the Flemish masters led to a decline in fresco painting and watercolor was relegated to a medium for doing preliminary sketches or as a tool for study.

It was the English painters of the eighteenth and nineteenth centuries who transformed watercolor into art work that once again was taken seriously. The English have a notorious love for the out-of-doors and also a great fondness for small, intimate pictures. The subdued tones of watercolor had a remarkably strong appeal for them.

Paul Sandby (1725–1809) is called the father of English watercolor. He was followed by men like John Robert Cozens (1752–1797) and Thomas Girtin (1775–1802). The two masters of English watercolor (which was the basis for American watercolor), were undisputedly Joseph Mallord William Turner (1775–1851) and John Constable (1776–1837).

Constable and Turner took their art outdoors and began working from direct observation of nature. They avoided the kind of stale, classicist subjects that had dominated European painting in the seventeenth century. Many critics consider, with some justification, Turner the true founder of "modern" art. Certainly, his colorful and semi-abstract paintings of ships and violent seas were the basis for Impressionism.

The American contemporary of Turner was John James Audubon (1785–1851), an ornithologist, whose renderings of the birds of the New World transcended their scientific intent and became fine art.

In the twentieth century, the United States supplanted England as the great center for watercolor. In large measure, this was true because of men like Winslow Homer, who was one of our finest painters, as well as superb artists like James McNeill Whistler, John Singer Sargent, and Thomas Eakins. Eakins has probably been the single strongest influence on Andrew Wyeth, the most widely acclaimed current representational artist.

The American Watercolor Society—of which I am privileged to be president—was founded over a century ago mainly to give watercolorists an opportunity to show their work and to develop their medium. Before its founding, the American public was hardly aware of the existence of watercolor.

Science has improved the tools of watercolor to the point where there really should be no argument about the permanence aspect of the medium. Watercolors are no longer done simply in transparent washes.

In fact, the word transparent is really meaningless now since plastic watercolor (acrylic) can be applied in transparent washes, although it dries waterproof, and avoids many of the problems one encounters in the old-fashioned aquarelle.

It sometimes strikes me as ironic that the invention of oil caused painters to abandon fresco in favor of the new medium. Now, with the invention of acrylic—which is a water-soluble paint—oil painters are returning to a form of watercolor.

What is a definition of watercolor? The American Watercolor Society defines it as "A painting executed on paper, in a water-soluble medium, unvarnished." That's about as specific as one should get.

Watercolor is, without doubt, the most popular medium today. It is one of great challenge and opportunity. In this book, I hope to tell you some things about using it to its full potential.

Prehistoric drawings in color from an ancient cave in the Lascaux region of France.

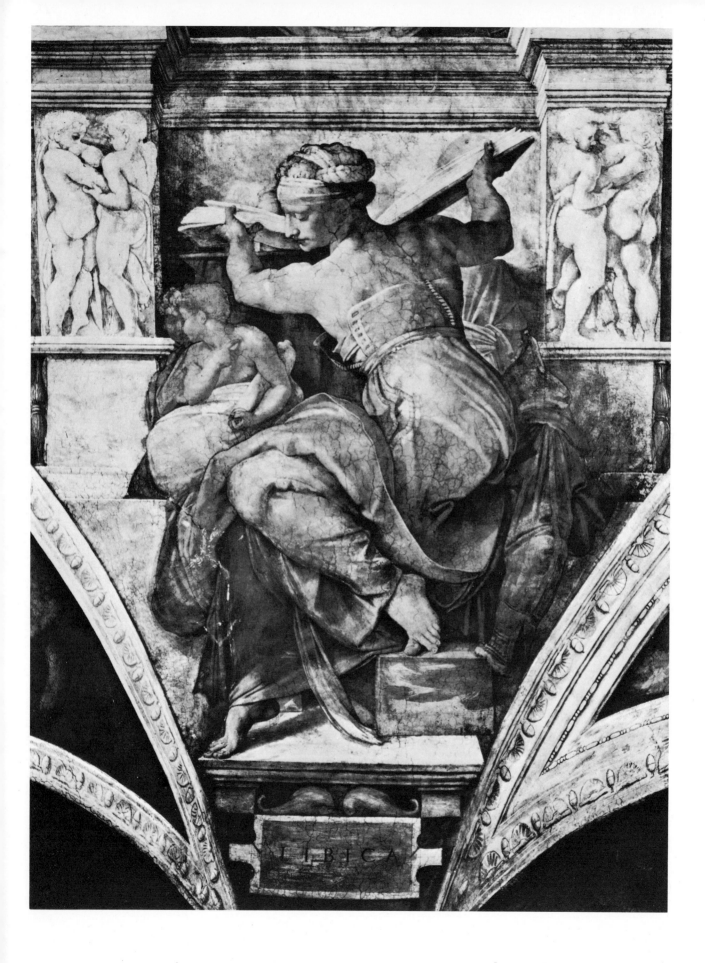

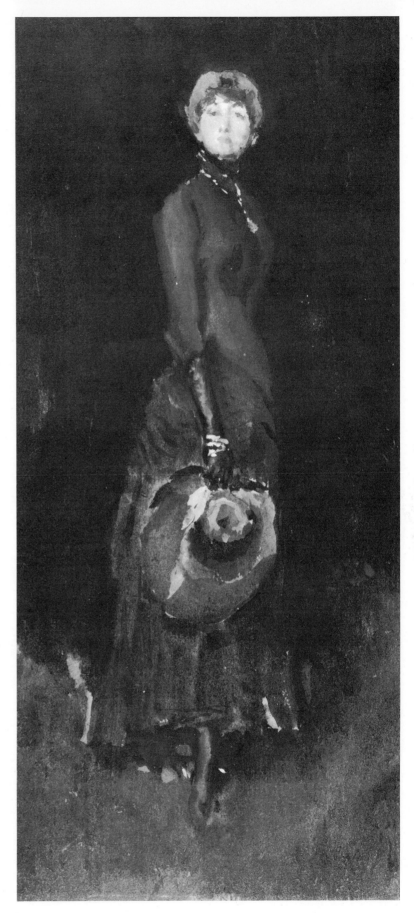

Facing page. Michelangelo: *The Libyan Sibyl* on the Sistine Chapel ceiling, 1508-1512. Michelangelo, Raphael, Piero della Francesca, and Uccello all painted large frescoes.

At right. James McNeill Whistler: *Lady in Gray*. Gouache on paper.

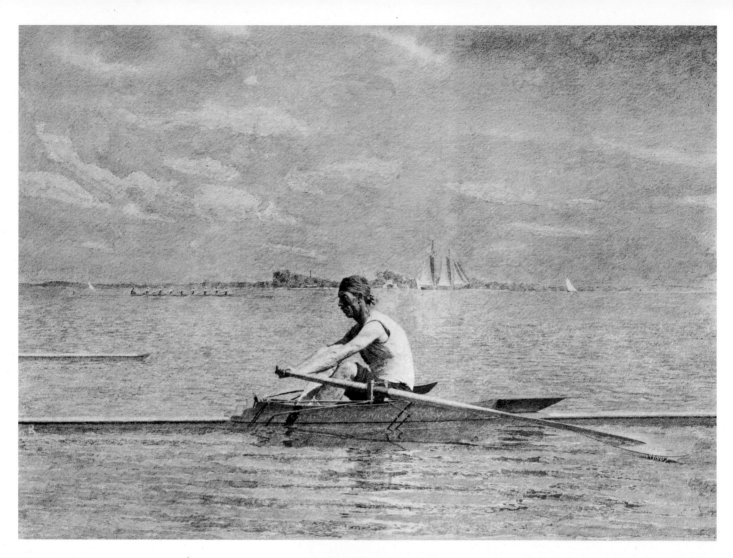

Thomas Eakins: *John Biglen in a Single Scull.*

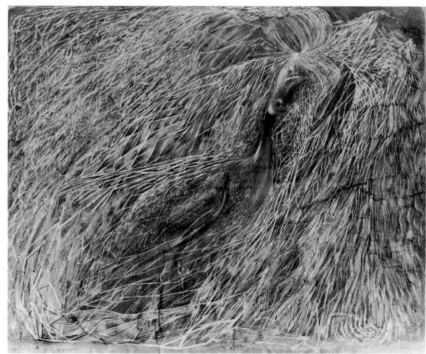

Morris Graves: *Bird in the Spirit.* Tempera on paper.

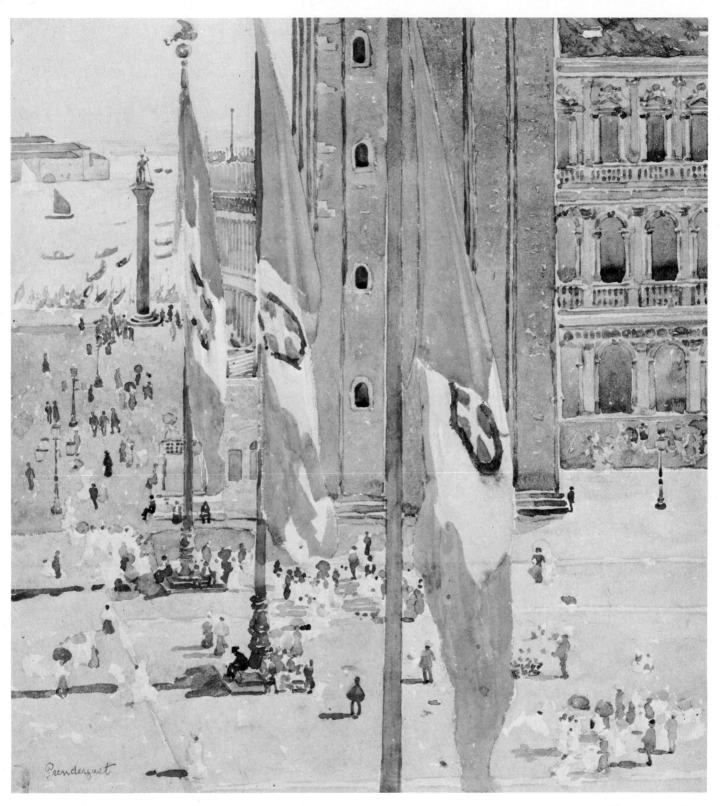

Maurice Prendergast: *Piazza di San Marco*.

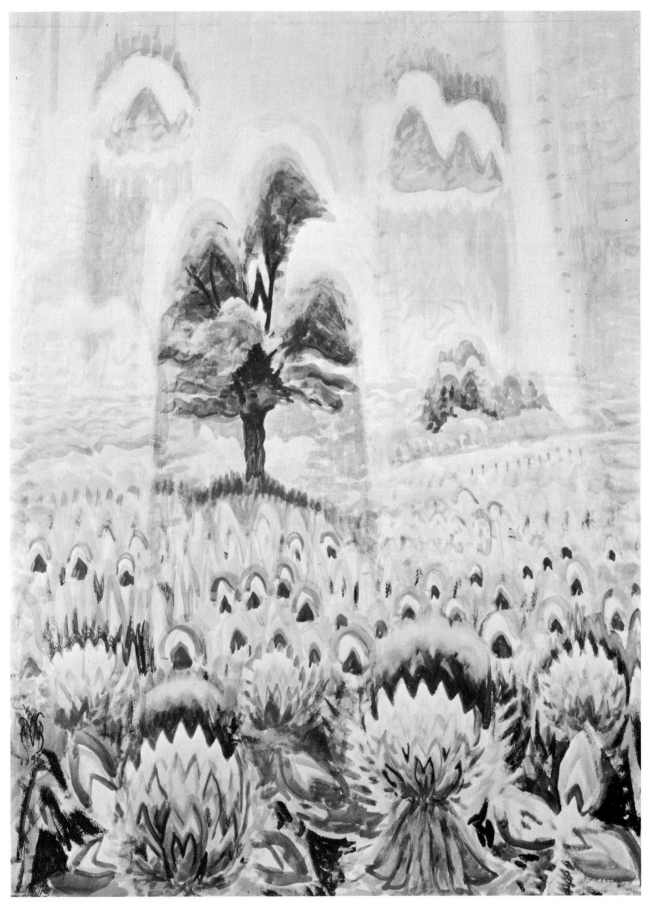

Charles Burchfield: *Clover Field in June, 1947.*

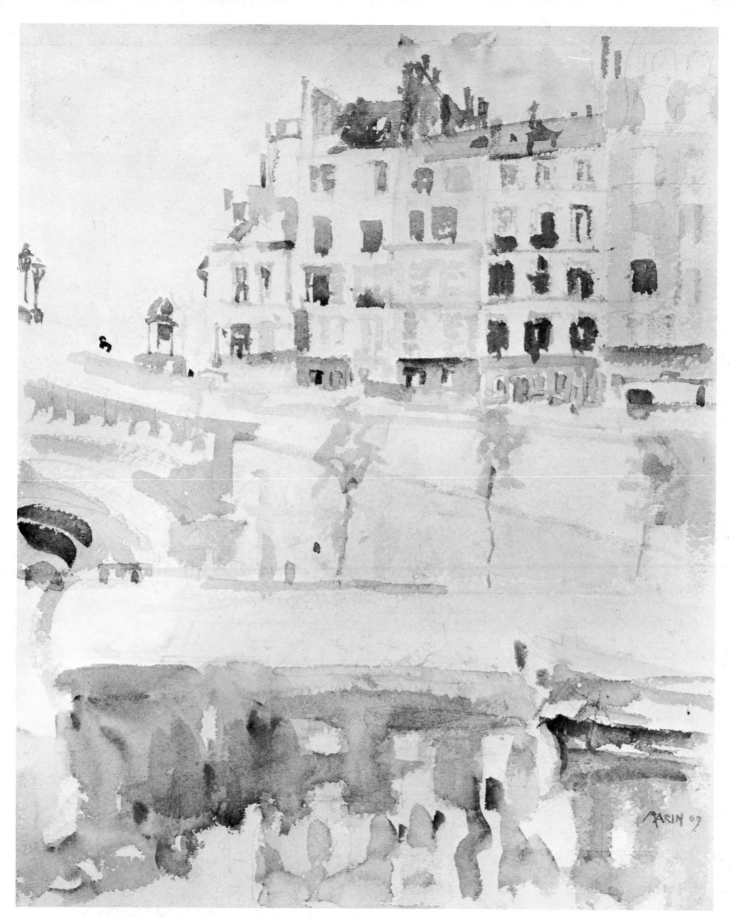

John Marin: *Along the Seine.*

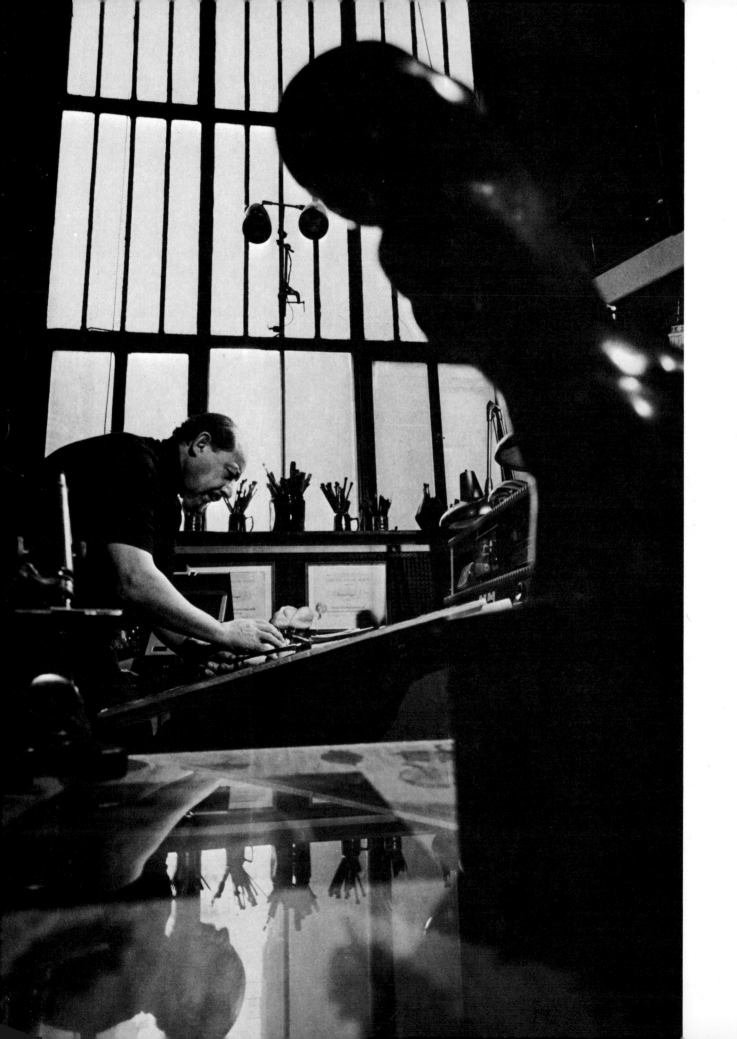

A misconception that many beginning painters have is that they will require a great deal of space and an incredible amount of supplies in order to get going. That simply isn't so.

A little imagination can almost magically transform a large closet or small storeroom into a perfect little atelier. Put a drawing board or easel into this area, add a minimum amount of supplies, and you're on your way. Nothing fancy is required. For example, you can make a splendid drawing and painting table by simply hinging a drawing board to any table.

Once you have the space and the table, supplies are the next order of business. Choice of paper is very important. Watercolor paper can be bought in single sheets or in "blocks." Blocks are usually twenty sheets, with glue all around the edges. When you paint on the block, the paper first buckles; it contricts when it dries and, since it is glued all around, tightens like the head of a drum.

Single sheets of watercolor paper come in varying thicknesses which are indicated by a weight number. That number indicates the weight of 500 sheets, or a ream. So 300-pound paper means that a ream of paper weighs 300 pounds.

Large sheets of paper that are 26½″ x 40″ are called "Double Elephants." An "Elephant" is 23″ x 28″ and a "Royal" is 19″ x 24″. The "Imperial," the size most frequently used, is 22″ x 30″.

One of the best papers is made by the French company, D'Arches, which has been in the business since the year Columbus discovered America (that's why 1492 appears on the pad). The British make a good paper called Whatman, and another good type is the Italian Fabriano, a very tough paper that will take a lot of punishment. The way to learn which paper best suits your painting style is to experiment with several until you find the one you like.

Single sheets must be stretched or taped down before they can be painted on. My suggestion is to wet the paper first, especially when using 140- to 300-pound weight. This will point out possible imperfections and open the pores of the paper. The thinner the paper, the more it will stretch. Just before the paper is completely dry, staple it to a three-ply board. I use stapling instead of taping because quite often I need all of the paper for a picture and it is quite simple to fill in the little white areas blocked out by the staples. With tape, you lose an inch or so of the picture.

When it comes to color, I try to use a very limited palette and the strongest tinting colors in their purity, avoiding fancy mixtures. The colors which a painter should have on hand are:

Lemon yellow, Indian yellow, cadmium orange, Winsor red, cadmium red deep, rose madder (genuine), alizarin crimson, raw sienna and burnt sienna, raw umber and burnt umber, Thalo green, Thalo violet, Thalo blue, French ultramarine, and — a favorite of mine — Payne's gray (a mixture of lampblack, Prussian blue, French ultramarine, and alizarin crimson).

As in selecting papers, choosing brushes is a matter of personal taste. Buy several and try them out until you find the type that responds best to your own technique. On last count, I had over two hundred brushes, but you don't really need that many. Watercolor brushes should only be used for watercolor.

For removing paint or softening an edge, I make a scrubber from an ordinary bristle brush simply by clipping it short. An ordinary household sponge is excellent for wiping the brushes. A natural sponge (facial sponge) is very useful in softening edges or in wiping out areas. Fine tissue rather than a paper towel should be used for lifting color from the paper.

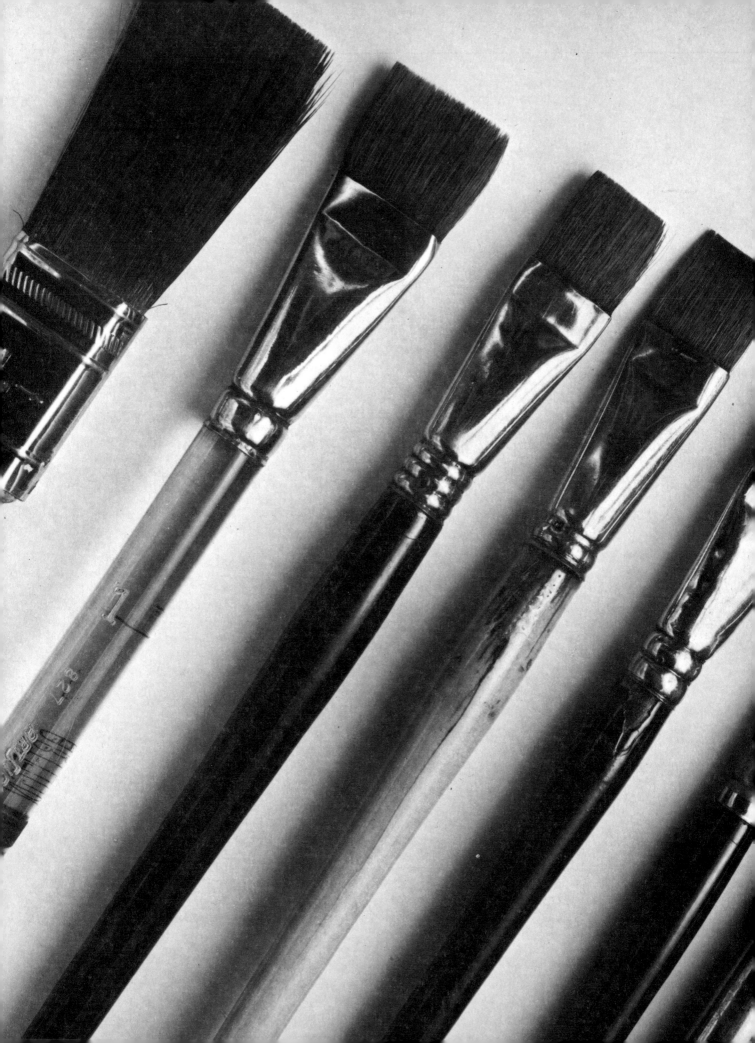

Here reproduced in slightly larger than actual size are the brushes I use in painting. From the left, they are: a $1^1/_2$" regular house painter's brush made of nylon, which is used to wet the paper. (Nylon hair has a lot of spring and is easier to work with.) The second is a bright (bright means short) 1" sable-hair brush. The third and fourth brushes are $^3/_4$" No. 20 sable hair. The fifth brush is a No. 18 and the sixth a No. 16. The seventh is a No. 15 round sable — which is very expensive — and the last brush is a number 8. Round brushes are better for working on a dry surface, as they hold more water. In a portrait, some of the details are painted with a No. 8 round sable brush (see top of page 125). On a wet surface use the flat brushes, since they can pick up more pigment, while the paper supplies the water.

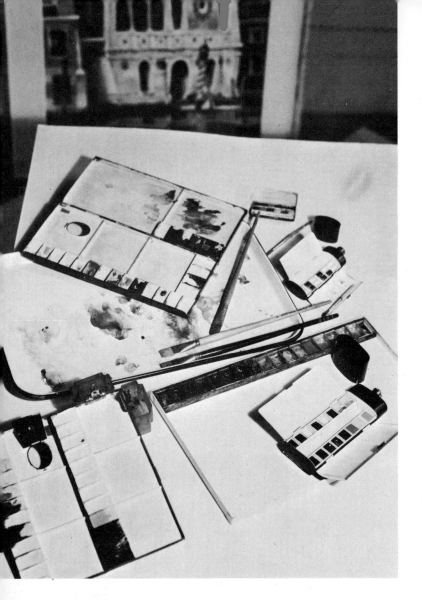

Shown above is a group of my palettes, which vary from a butcher's tray to a vest-pocket Winsor and Newton. With clock times denoting positions, they are: seven o'clock, a British-type folding palette (this is the larger size); nine, the butcher's tray; eleven, a smaller version of the British palette; twelve, the vest-pocket Winsor and Newton; one, a small metal water bottle whose exterior turns into a palette; three, a flat mixing tray with a magazine that holds metal trays for color; and four, a larger version of the aforementioned water bottle. This one has a cover that serves as a little water container and can hook onto the side of the mixing surface.

At right, you can see my side table, with the corner of a ¼″ plywood panel at eight-thirty which has a sheet of 300-pound Arches paper stapled to it. A drawer that contains tubes of color is under the butcher's tray, and toward ten o'clock there is a drawer that has two plastic water containers, one to be used in painting and the other in cleaning brushes. I work with a sponge instead of a rag. At ten-thirty on the table, notice a pair of opera glasses; I need these in order to read the labels of information files on top of my ten-foot bookcases.

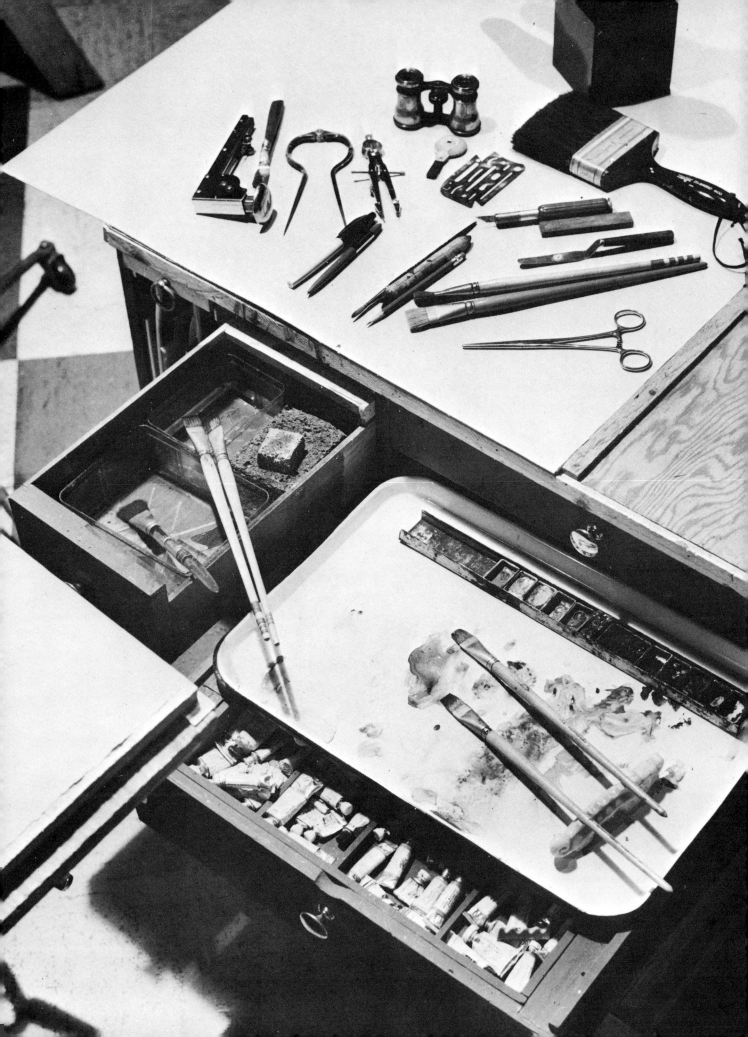

The seven sheets of watercolor paper on the opposite page are, from top left: 200-pound Fabriano, handmade in Italy; 300-pound Whatman, handmade in England; 140-pound Arches, handmade in France; and 70-pound Arches. The next two are 140-pound and 70-pound commercial paper, which is machine-made.

In the sketching gear on location shown below, the easel is made from a photographic tripod and a three-ply $\frac{1}{4}''$ panel that is used for the table section. Attached to the table with a bolt wing is a folding palette that has two plastic containers clamped to it. A watercolor block of twenty-five sheets (10″ x 14″ 140-pound rough Arches) is held in position by two sliding wooden bars. A brush container made out of canvas, a tablet for taking notes, a leather paint case, and a canteen are on the ground, and in the background is a folding carry-all stool.

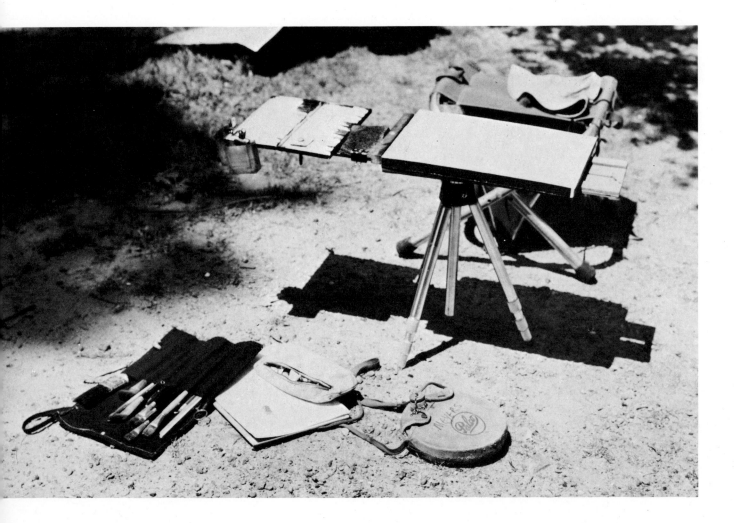

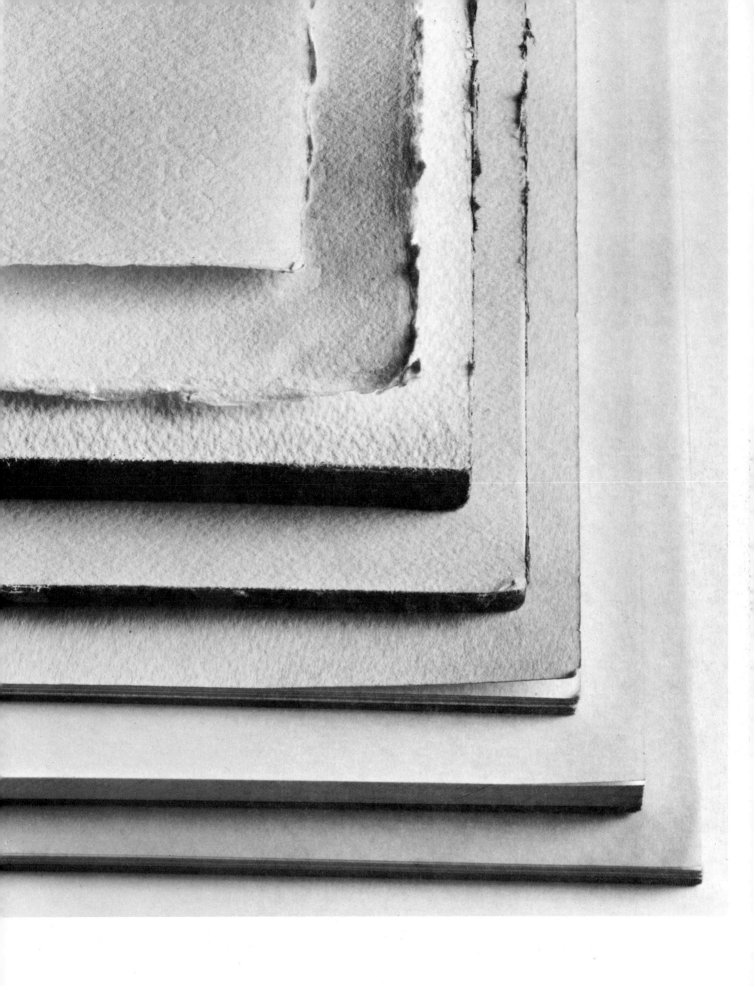

The portrait to which I am applying finishing touches is the one on page 129. My studio has a desk (at left), which I use for handling business matters and correspondence, and behind my head is my 35mm. slide viewer. My desk palette is a white enamel butcher's tray.

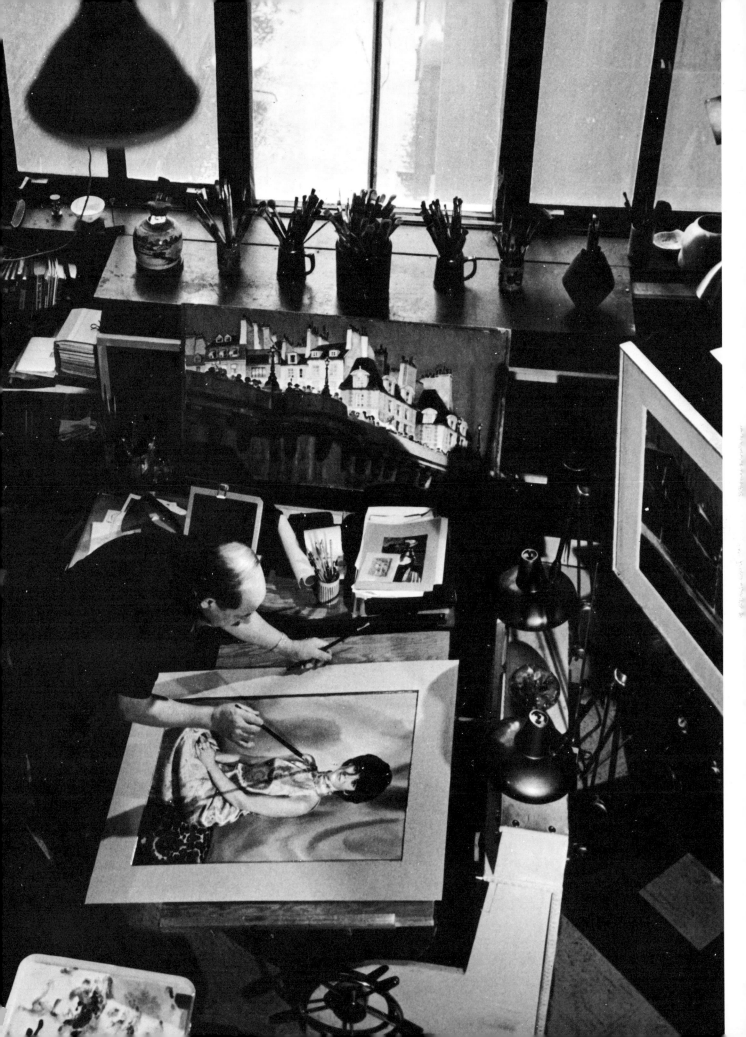

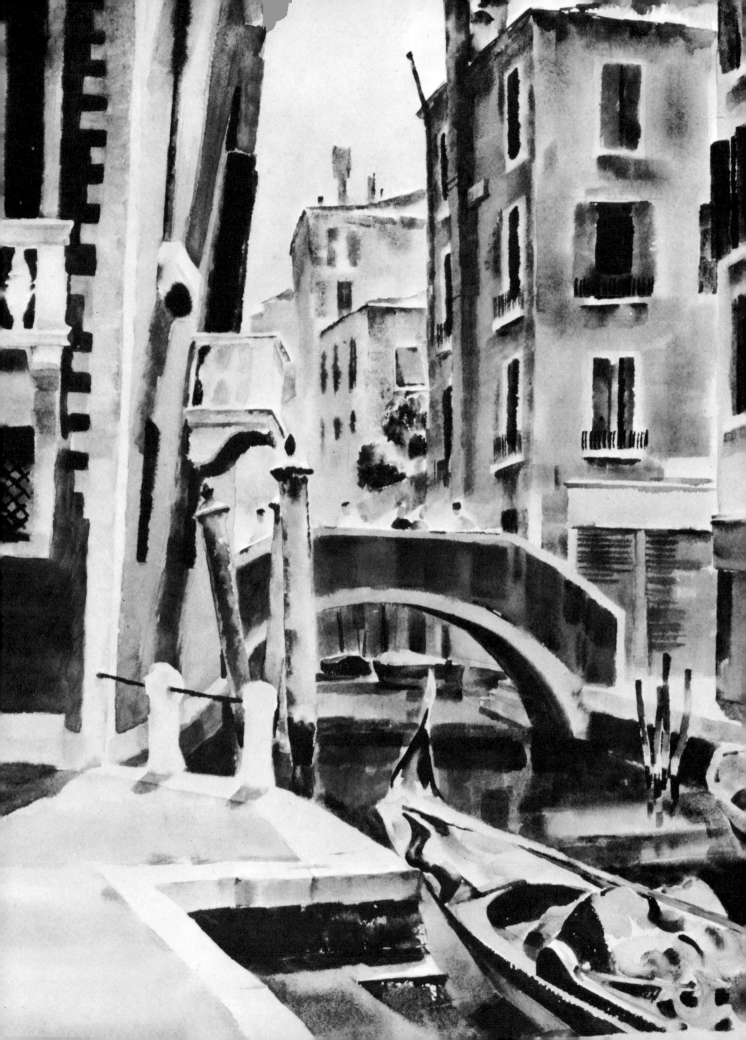

Paul Cézanne, the great French Impressionist, once observed that the triangle, the circle, and the square are the bases for all design and composition. Oriental cultures had, of course, recognized this idea long before Cézanne. In Japan, these symbols are part of the language. The triangle means heaven, the circle is man, and the square is earth. A combination of these forms is the basis for the Japanese lantern and — more importantly — all thinking about design.

A definition of composition is elusive. A distinguished art teacher once told me — when I asked him to recommend some good books on composition — that there were none. "But I can tell you this," he said. "Tell one story at a time."

Following this thought, I often tell my students that Clyde Beatty, the great lion trainer, used a chair not for protection from the big cats but because the legs had four points, which served to confuse the animals.

The aim in composition is not to confuse, however, and so a good composition is one that has just one point. It should have three main parts — the major, intermediate, and minor — in order to make this single point.

A design which does not have a focal point, or "the eye of the picture," is simply decoration, like wallpaper. To illustrate the difference between decoration and composition, imagine a checkerboard with black and white squares of equal size printed on rubber that is flexible. Attach this to a frame and imagine that someone is behind it, pinching part of the checkerboard toward him and with the other hand pushing another section away from him. The result, as you view it from the front, is that the square that is being pushed will become the largest and the square that is being pinched will become the smallest. This creates the three major points: largest, smallest, and intermediate. You have, in effect, created a composition. (See page 29.)

Light and shade are powerful forces in design; however, they can be destructive if used improperly. Light and shade as light and shade have nothing to do with art or design; (if they do, it's merely an accident). They are helpful to composition only when they become forces that are dynamic and alive and colors that help other colors realize their potential.

Remember that composition can be reduced to the simple elements of geometry, such as cylinders, cones, cubes, and spheres. Try to see these basic shapes in your picture.

It is also useful to think of compositional elements in terms of the number three. If an area is divided in half, you have simple confusion. If something is divided into three sections, you may still have confusion but it is a more interesting kind of confusion. If we use tones such as black, white, and gray and we apply them to these three equal areas, we have three areas of the same importance saying three different things rather than one major thing.

The following simple formula might be of some help in accomplishing a major picture statement. Divide a rectangle into nine equal bands. Use one band for one of the three values mentioned above, then double that area and use one of the remaining values. Multiply this area by three and add the remaining value.

Circles and ovals play an important part in the definition of form and terrain. Imagine a coin bracelet wrapped around a cylinder. The top and bottom coins appear to be in perspective while the coins in the middle area appear to be circular.

One last compositional concept that you might consider is the use of letters as a design element. The Chinese and Japanese, as well as people of the Middle East, are taught the power of using letters and alphabets by their calligraphy, which is exquisite. Many contemporary painters, like DeKooning, Jasper Johns, Robert Rauschenberg, and Arakawa, have rediscovered what a powerful statement language can be when used in design. Think of the dynamics of the letter "K" or the active movement of the letter "W." The next time you see a painting that interests you, see if you can make out letters in it. Whether put in intentionally or unconsciously by the artist, you will often find them there.

Venice Canal. I painted this scene from slides and sketches in the studio, on a half sheet of Arches Imperial 300-pound paper.

Shown at left below, the three bases of design, as used in the Orient, are in Japanized Chinese: The triangle, *ten*, meaning heaven; the circle, *jin*, meaning man; and the square, *chi*, meaning earth.

On the right, the three elements put to practical use make a Japanese lantern.

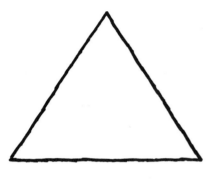

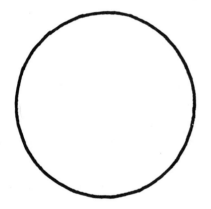

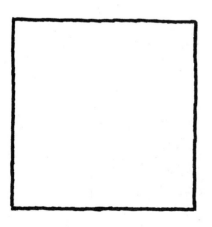

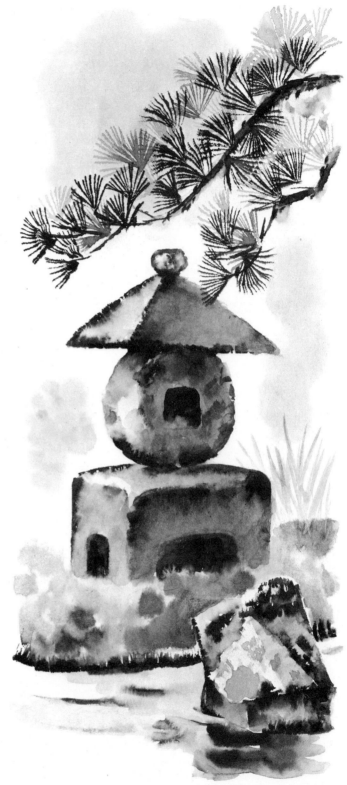

When pushed and pulled, an imaginary checkerboard made of rubber makes squares of different sizes. Together these add up to a composition because there is a dynamic relationship between the major and the minor squares, with the intermediate ones acting as their foil.

A checkerboard with all squares of the same size makes for decoration. You can remove any of the squares without disturbing the design, since there are no dynamic relationships.

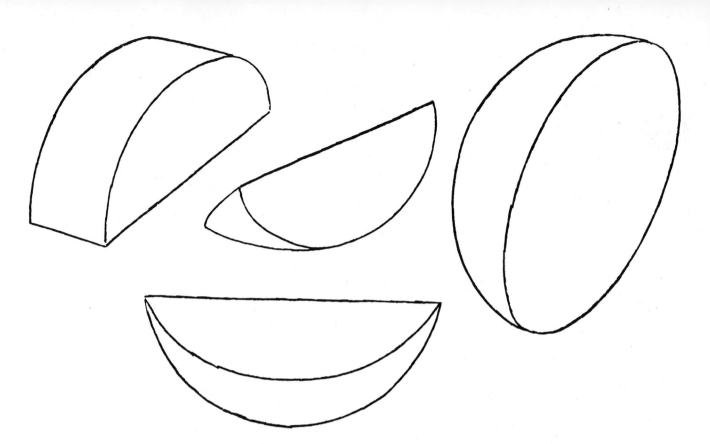

Strictly linear drawings do not have the feeling of weight that drawings suggesting light and shade do. Below, the arrows point to the edges that are diffused on one side. This diffusion keeps the eye on the design, rather than having it jump to the background.

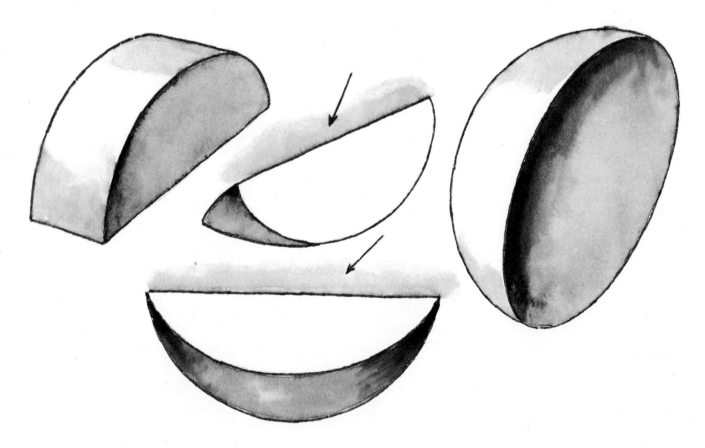

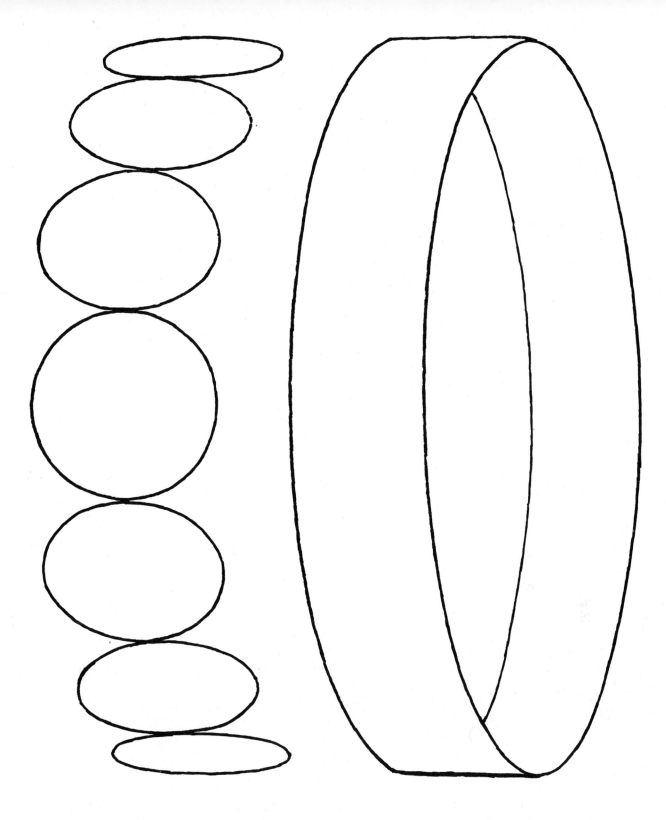

Shapes suggest positions. For example, a circle will suggest a vertical position, while an oval suggests the horizontal. The latter can also represent a circle in perspective, as with some of the coins in a coin bracelet worn around the wrist.

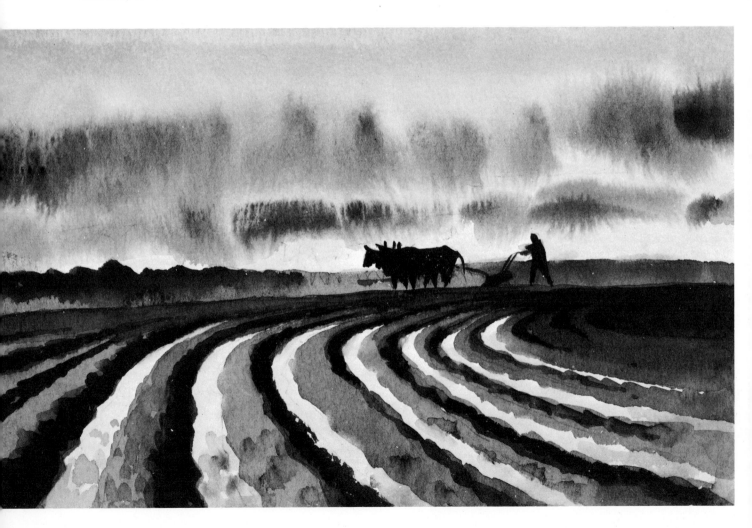

The three equal divisions at left are interesting, but not dynamic. You can divide the area into nine parts as shown on the right.

Here, a picture using the kind of composition described above will almost be divided in the middle by the horizon.

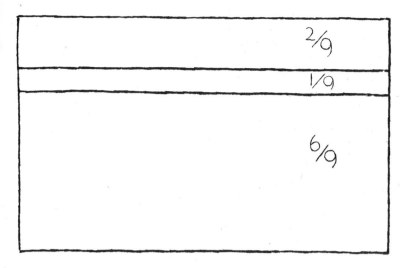

Now, take two of the ninths and make them gray, leaving one white and making the remaining six-ninths the important part of the picture; this makes for a dynamic division.

Compare the resulting picture below with the one on the opposite page, and decide which is the more powerful.

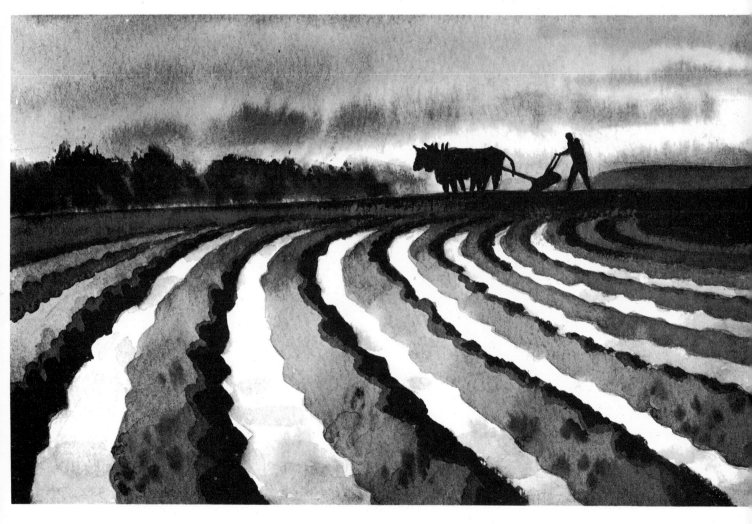

Take these black and gray elements —

Place them in a tasteful arrangement —

In this common error, the lake has been made too round, thus suggesting a vertical position rather than a horizontal body of water.

This shows what can be done with little.

Here, the horizontal oval suggests a circle in perspective. You will have to deal with this problem of perspective when you paint inlets and bays.

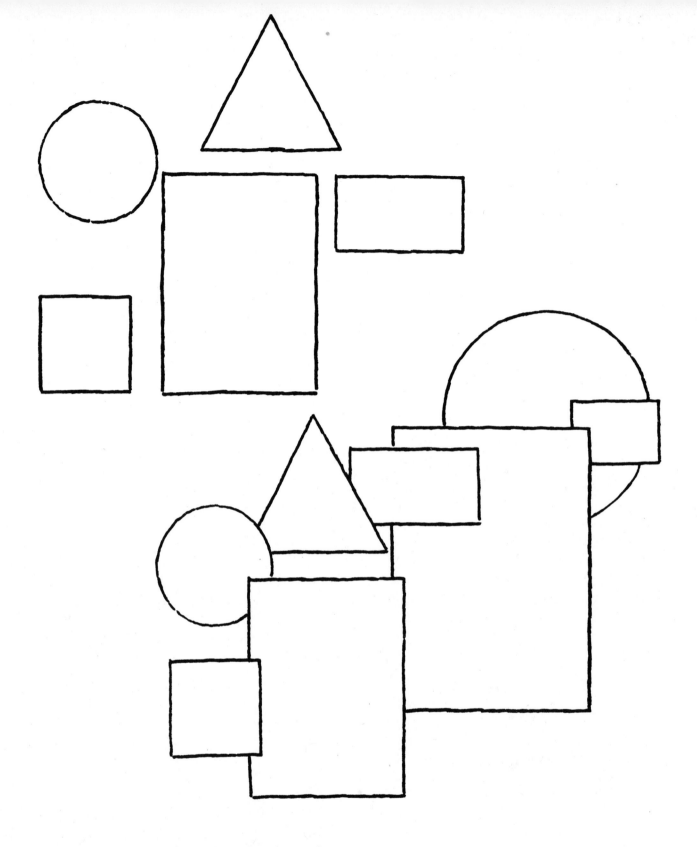

There is no way of knowing the relationship of size and position — or what is known as spatial perspective — among the five geometric figures at the top. By overlapping the figures on the bottom, however, you can distinguish their relative sizes and positions — noting, for example, that there is a big circle in back and a small square in front.

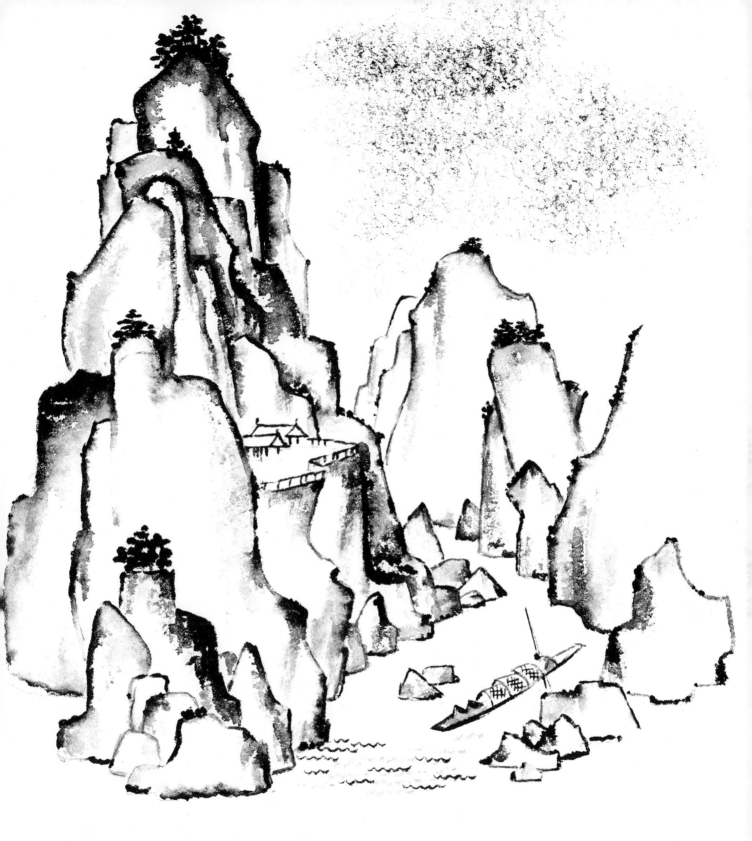

The Chinese, who have always been very skillful in
rendering spatial perspective, could place elements in the
distance without the use of vanishing points. We always
think that a small object is in the distance while the large
one is up close, but in this landscape in the Chinese style,
I've shown how, with overlapping, this is changed.

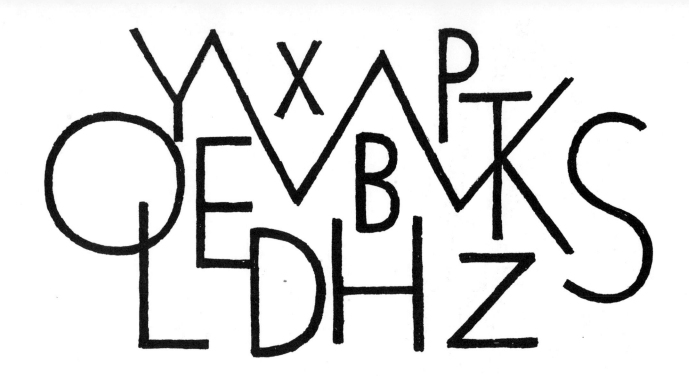

In the lower drawing of a dock in Peak's Island
I used most of the letters on top. See how many of
them you can find.

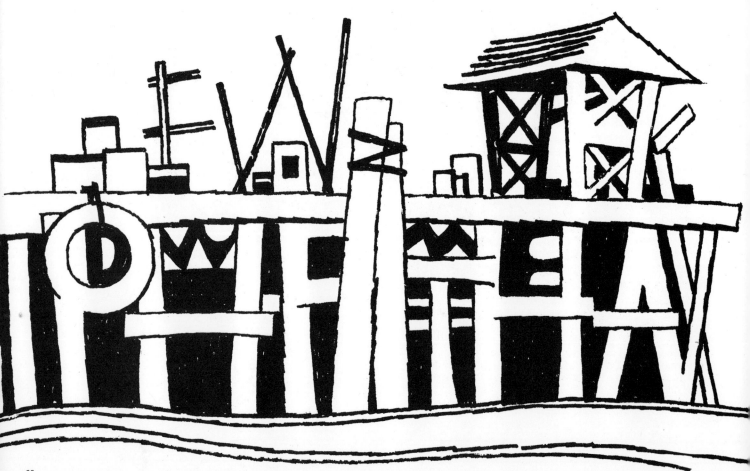

Composition and design are the bases of every picture, but it is color that brings a subject to life.

Before you can understand color, you must know the vocabulary. What is meant by words like tint, shade, tone, and hue? Here are some simple definitions:

Hue is the color as it comes straight out of the tube. If you add white (as in oil colors), and only white, you will have a tint. The more white you add, the lighter the tint. In watercolor, thinning the pigment with water creates a tint. Shade results from adding black to hue. Again, the quantity of black (or its equivalent, such as the mixture of blacks, blues, and reds in Payne's gray) makes it a darker or lighter shade. A gray color added to hue gives you tone and once again the degree of tone is determined by how much gray is added.

The term "triadic" is applied when three colors are used well removed from each other along the color wheel; "complementary" when colors oppose each other, as magenta and green; and "analogous" with colors that are closely related, as yellow and green, or **yellow and orange. (See page 67.)**

Value, the lightness or darkness of a color, is produced by the intensity of light on or from a color. To best illustrate the variations of value, I have used, for their simplicity, black and white as examples, on the theory that white represents the presence of light and **black represents its absence. (See page 44.)**

By surrounding a white area with darker colors, that white area can be made to appear even whiter. It is surprising how many established painters do not know how to utilize this simple concept.

There are many artists who do understand the importance of value and have utilized it to create unforgettable pictures. Rembrandt, for example, went directly from white to black, almost eliminating the center portion of the scale except where it was used to meld the black and white together.

On the other hand, the school of Corot used only the values in the center of the value scale or, to be specific, gray. White and black were used only as minute accents, such as the color of hair, or of a small figure, or a black skirt and a white blouse.

Another easy way to think of color is in terms of film, volume, and surface.

The term film color describes the effect produced in painting such things as sky, fog, and mist. Volume color describes buildings and trees as they appear through a translucent film. Surface or local color is the color of anything as it appears. Fog by itself is film color but a building or tree seen through the fog has volume — a suggestion of three dimensions.

In real life and in paintings (if the artist's perception has been adequate), wet surfaces or metallic surfaces turn themselves into mirrors. A wet pavement reflects film (sky), volume (buildings in the distance), and surface (the color of figures). Just how this works is **demonstrated by the painting on page 43.** The important thing to keep in mind is that a metallic or wet surface almost loses its own color identity.

Colors are like prima donnas. There can only be one bright one, or one in pure hue, and it will barely tolerate its neighbors. Orange will accept a little bit of yellow or a little bit of red. But the further away you get from orange on the color wheel (or the closer you get to its complement), the more you will have to use tint, tone, or shade.

These color concepts are at variance with the body of scientific color theory and there are many fine books available which can give you more details, if you wish.

Experimentation with mixing and applying colors is the best aid of all in learning about color. Don't be afraid to try different or difficult things.

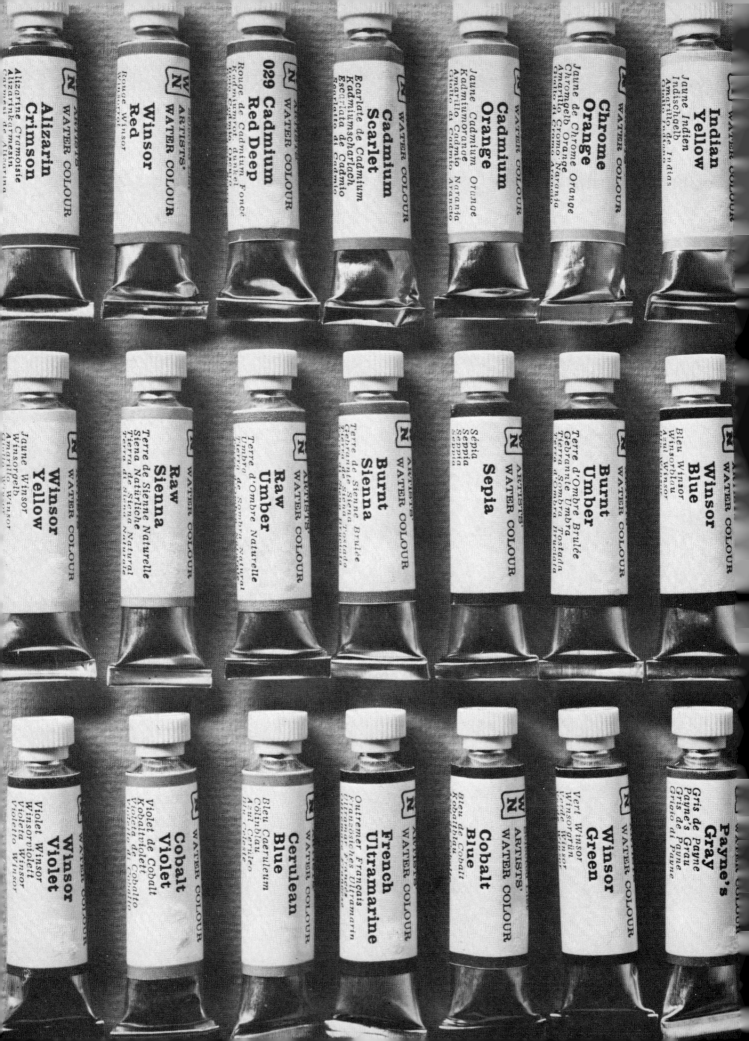

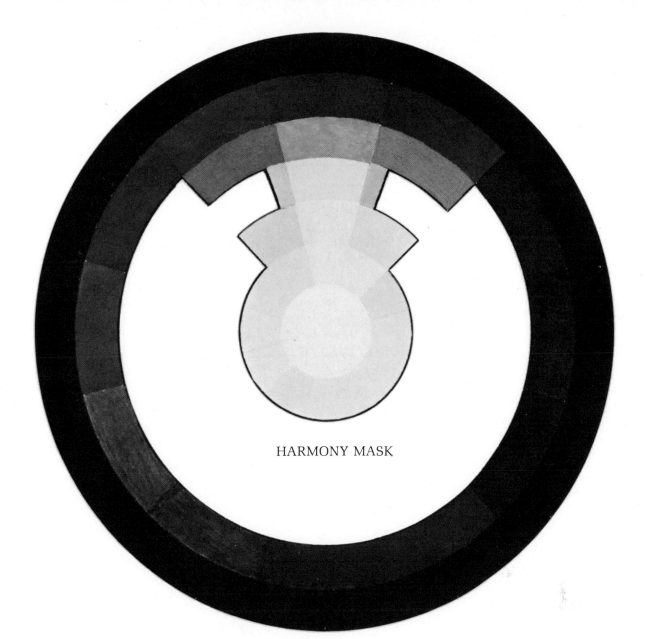

HARMONY MASK

After tracing the harmony mask above on a piece of tracing paper with an ordinary pencil, transfer it to a piece of white drawing paper by turning it over, so that the pencil lines are in contact with the drawing paper. Then, with a ball-point pen, trace the outline of the mask; this will press the pencil onto the drawing paper. Cut out the mask and it will be ready to use.

As you use the harmony mask on the color wheel on page 67, make sure it spins on its proper track as shown above. You will notice that the mask projects further along the hue track, and also that the hues will tolerate a little of their immediate neighbors. Rotate the mask and stop at any hue, and the colors exposed will harmonize with it.

Although the tubes of colors photographed on page 40 are the ones that make up my palette, I seldom use them all. It is almost impossible to get "mud" with any of their mixture, since they are all pure pigment — except for Payne's gray.

I am always appalled at an artist who has eight or more tubes of different kinds of green. You only need one green — Winsor green (Thalo in some brands), which is made of chlorinated copper phthalocyanine. This color has great tinting strength, and when mixed with Payne's gray, it becomes a rich black green; when mixed with raw sienna, it becomes olive green. Try mixing Winsor green with the following colors (and make some color brush notes of their mixtures, as on page 66): burnt sienna, raw umber, lemon yellow (Winsor yellow), Indian yellow, cadmium yellow, cadmium orange, cadmium scarlet, and so on, and you'll find you don't need a fancy mixture of greens in tubes. Try mixing the same group with Winsor blue (phthalocyanine — "Thalo"); this color, like green, is very powerful. One of my favorite mixtures is Winsor blue with alizarin crimson — it's called steel; try a thick mixture and also a thin one.

One color with great versatility that is not fully explored is raw sienna. It will do everything yellow ochre will do, but without muddying. In painting yellow objects or flowers, sometimes you need dark accents of the color; raw sienna will make for dark accents without looking brassy.

Lampblack is made from hydrocarbon, and ivory black is made from the calcination of bones. You can see why when colors are mixed with black, they can easily get muddy, and that is why I do not recommend it. This doesn't mean that black should never be used; it only means you had better have a good reason. Instead, I usually recommend you use Payne's gray, which is made up of lampblack, Prussian blue, ultramarine, and alizarin crimson, so that the lampblack is completely overwhelmed by the other colors. It has a slight blue cast when used by itself, but I usually add alizarin crimson or burnt sienna. When I want a real black, I use Payne's gray, alizarin crimson, and a very thick measure of Winsor blue. A very rewarding exercise — the kind I have done on page 66—is to mix a series of paints and put the results in a book. How do you get pink? Just mix water with any bright red, preferably Winsor red.

If your tendency is to paint with gray colors or very pale or very dark colors, you have no color problem, since all grays (tones) harmonize, as well as all pales (tints), and all darks (shades).

But when using bright (loud) colors, that is, colors in their full hue, you must remember that such a color can tolerate only a little of its immediate neighbors, as for example yellow tolerating a little orange on one side and a little yellow green on the other. (See the color wheel on page 67.) The further away around the color wheel a color gets from an intense hue, the more it will have to do one of three things — get lighter, grayer, or darker. Take the yellow on top of page 68. Yellow will tolerate a little yellow green, but not green; so green has to do one of those three things, or even all three, as long as it stays away from its full hue. Further along, going clockwise, we come to blue — which is really getting around the color circle; so blue will have to be lighter, grayer, or darker. As we continue clockwise, we come to violet, which is opposite yellow and so becomes its complement, and therefore must almost disappear into tint, tone, or shade. On top of page 69, the bright color is violet, and now yellow has to get lost in tint, tone, or shade, since yellow is the complement of violet.

If you take a bright red and place a neutral gray next to it, the gray will appear greenish. The very same gray placed next to green will appear red. If you paint a bright red rose and you add neutral gray leaves, they will appear to be a soft green. To make a more positive green, you would only have to add a touch of green to the gray, obtaining a green that won't fight with the red. The same holds true for any other complement.

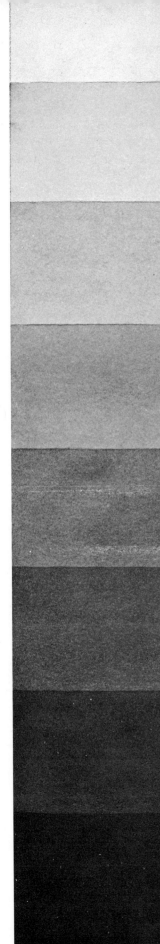

HL

L

LL

HG

G

LG

HD

D

LD

The painting on the facing page shows the sky (film); buildings in the fog (volume); and the umbrella, mailbox, and the woman's coat (surface).

Value (the intensity or lack of light), is so important that paintings can be made using just value, that is, white, black, and their mixtures. Therefore, you should learn a value scale, such as the one at left, that demonstrates the steps from white to black. I've used only nine steps, since any more cause confusion in distinguishing between any two steps, and I've given the steps new names for the sake of simplicity and clarity. The initials stand for: HL: high light; L: light; LL: low light; HG: high gray; G: gray; LG: low gray; HD: high dark; D: dark; and LD: low dark. Highlight is equivalent to the white paper and low dark to black paint. We have three lights, three grays, and three darks, and when these nine values are applied to colors, the combinations and color varieties are endless.

Some artists prefer to use only a section of the value scale. True chiaroscuro can be found in the work of Rembrandt and Caravaggio, who used only the high light and the low light, ignoring the gray tri-value except where it was necessary to join white and black. On the other hand, Corot and his school used the center of the value scale and thereby gave their paintings a silvery gray appearance.

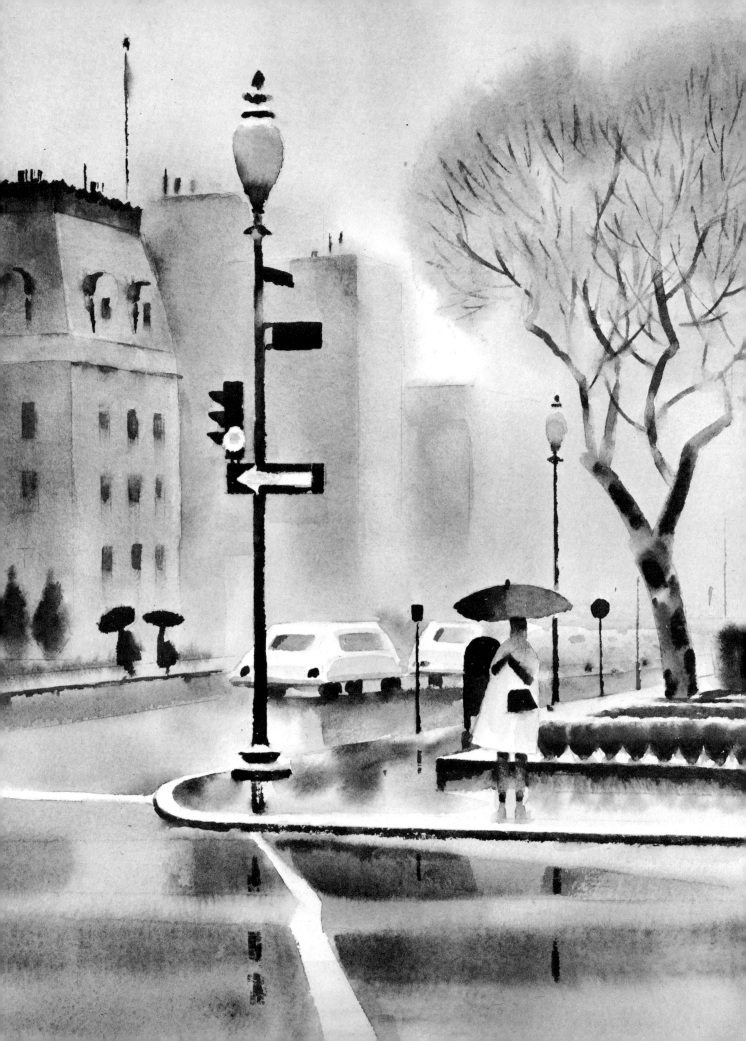

The technological revolution has not made the artist obsolete, as some would have you believe, but it has made his tasks a great deal easier.

Science has come to the artist's aid, not only with new and refined colors and color processes, but also with an infinite variety of handy gadgets.

One of the handiest of these is the camera. Not so long ago, artists feared this little rascal. It has eliminated portrait painting forever, they said. It has killed representational painting, others said. These deaths, to paraphrase Mark Twain, are greatly exaggerated. But even today there are artists who won't admit that they use a camera as a visual record.

Whenever I travel, I always take two 35mm. cameras with me, mostly to collect material for future paintings. The camera is a great timesaving device since, in a second, you can capture the exact detail of a street scene and you have it recorded forever. This leaves you free to sketch and to concentrate on the feeling or mood of the scene. Otherwise, you would spend hours just recording what you see by sketching. This is simply too time-consuming and completely unnecessary.

The best kind of camera for travel is a 35mm. since it is compact and easy to carry. This size camera comes in two types: the rangefinder variety and the single-lens reflex (SLR). The advantage of the SLR is that it allows you to see exactly what you are going to take a picture of, since, through a mirror system, one looks right through the lens.

The rangefinder camera is more difficult to use since you line up the scene in a separate opening. This makes photographing paintings in a museum particularly difficult because you may well cut out half of the painting and won't know until you have your films developed. Rangefinder cameras are also more difficult to focus.

In traveling, I also carry two or three sketch pads, including a hard-bound sketchbook which becomes part of my sketchbook library. Such a sketchbook is good to record your verbal impressions in as well as your visual ideas.

Other items one should carry are felt-tip pens, ball-point pens, a camera case (which can double as a miniature drawing board), a small plastic bottle (about 6 ozs.) containing water, seven- or eight-power binoculars, and a vest-pocket watercolor box, which looks something like a toy but is actually quite useful and functional.

You will also find a journal to be of immense help in recalling details and moods of places you visited. Often, when traveling with a group, you don't have time to really comprehend all that you see. Recording quick impressions and then rereading them later can help you understand what you have seen.

In sketching details on the spot, you will find binoculars particularly handy. For sketching a particular kind of finial on a spire or the top of a flagpole or fluting on a building or inaccessible terrain, the binoculars serve as an extension of your vision.

Aids which you might keep around your studio are a table slide viewer, which allows you to view slides without projecting them over a long area, and a microscope.

With a 50-power microscope, which is as much as you will need, you can search out and study details in color slides that are invisible or so small that they aren't useful through simply projecting the slide. Often I have found details in slides that I didn't really notice when the picture was taken. Mechanical aids such as these can significantly increase your effectiveness as an artist.

The painting on the facing page shows the sky (film); buildings in the fog (volume); and the umbrella, mailbox, and the woman's coat (surface).

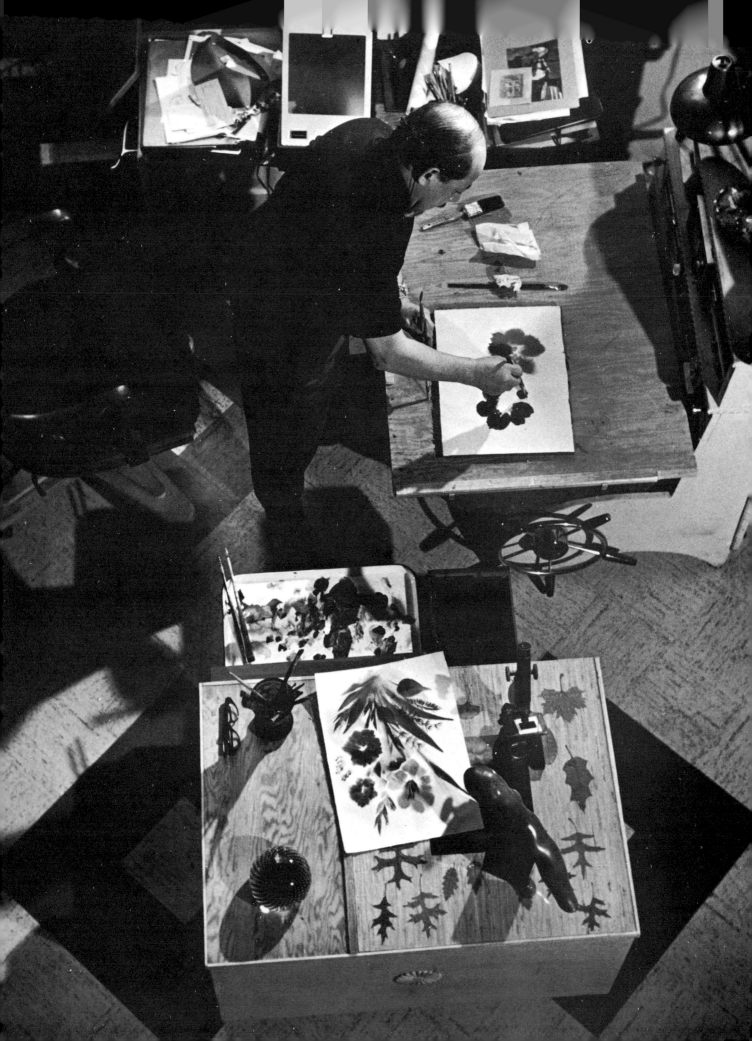

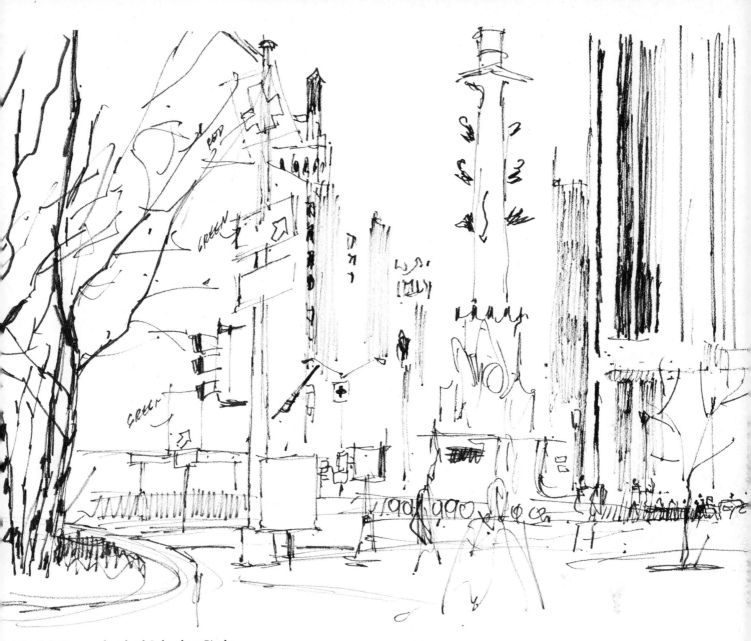

This felt-tip pen sketch of Columbus Circle
in New York City has notations for a later, more
detailed painting. It is this kind of quick study
that you can get down in a sketchbook that you
should always carry with you.

I can control the height and angle of my drawing board with a turn of the ship's wheel. I
designed and made this console, with its head panel that has a radio, small television,
electric pencil sharpener, electric clock, nine small plastic drawers, electric outlets and
control switches, and two adjustable lamps. Note the microscope on the table in the fore-
ground.

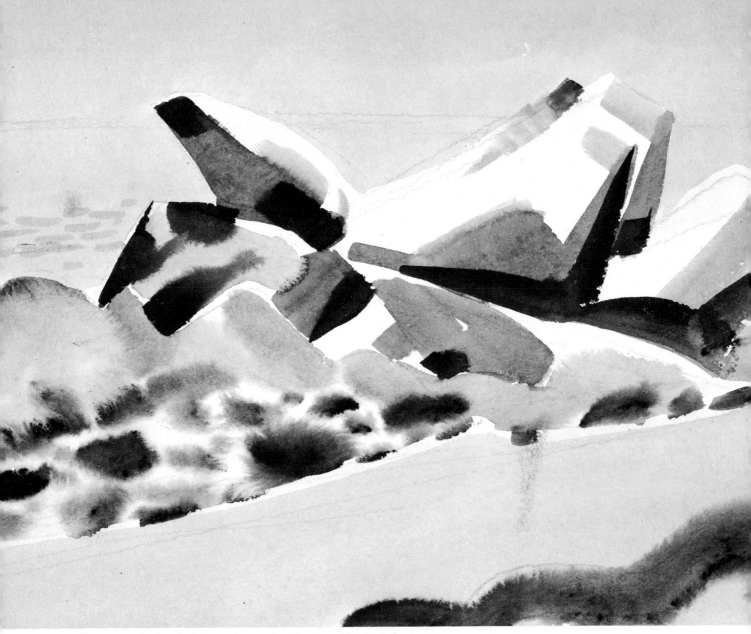

A diagrammatic sketch of the rocks, sand, and water at Peak's Island.

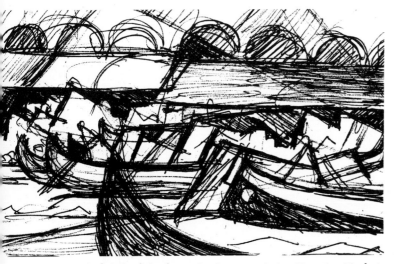

A sketch of the dynamics for my painting *Venetian Market*.

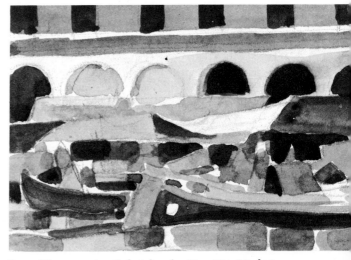

One of the many tonal sketches for *Venetian Market*.

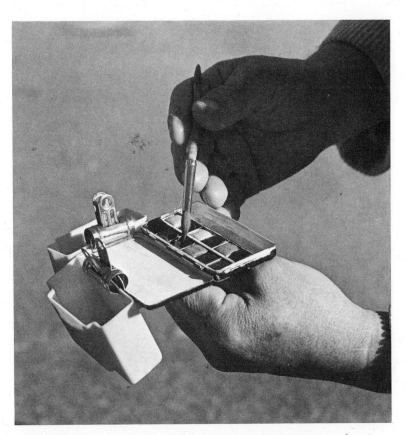

Two plastic water containers (large enough to hold a cigarette package)
are attached to the vest-pocket paint box by two little clamps.
Underneath the box there's a ring for inserting the thumb.

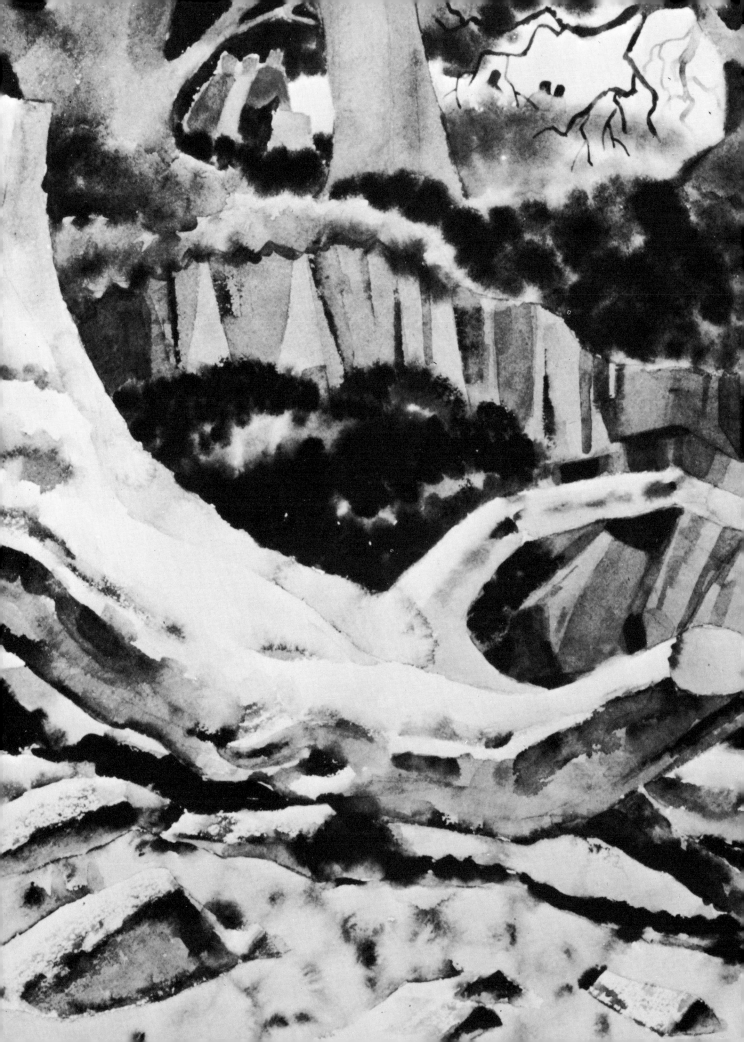

Fallen Tree on Peak's Island Beach.

A camera is one of the most useful tools an artist can have. However, one should remember that it is just that — a tool to be used as reference or an aid to memory. Great paintings come from the artist's imagination and from the personal interpretation he brings to a subject. A camera might help you copy nature exactly but it does not necessarily mean that you will have created a work of art. I frequently carry a 35mm. camera with me in my travels in order to record a scene I might otherwise forget. Having this handy record frees my mind for the more important tasks of feeling the mood of the scene and for sketching.

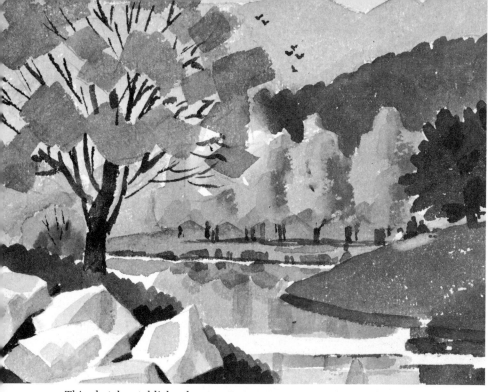

Piccadilly Circus. Thumbnail sketch.

This sketch establishes large pattern areas.

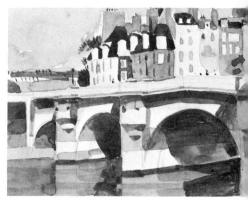

Pont Neuf, Paris. Thumbnail sketch.

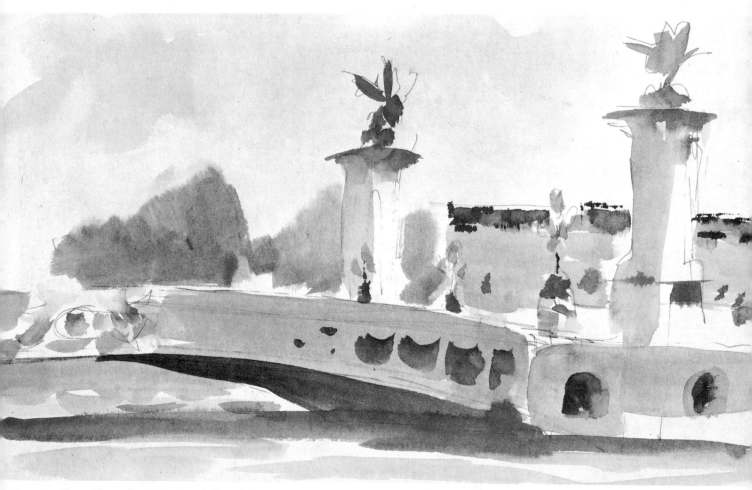

Pont Alexandre III. I painted this with pen and vest-pocket paint box on a sketchbook page.

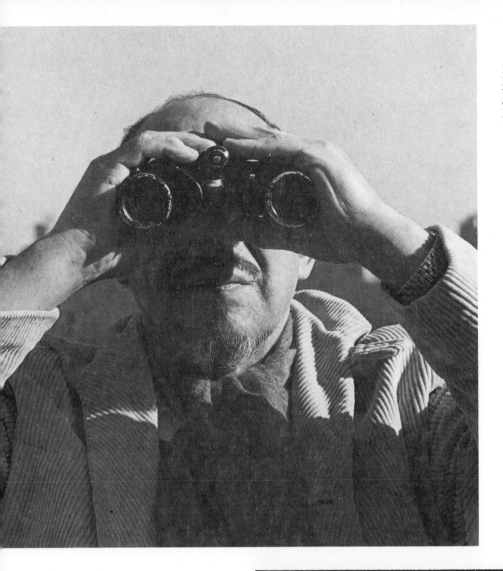

From the top of Russian Hill in San Francisco, I used 8 x 30-power binoculars, in order to bring the Coit Tower close enough to enable me to do the sketch below.

I sketched the Coit Tower exactly the same size as it appeared in the field of the binoculars.

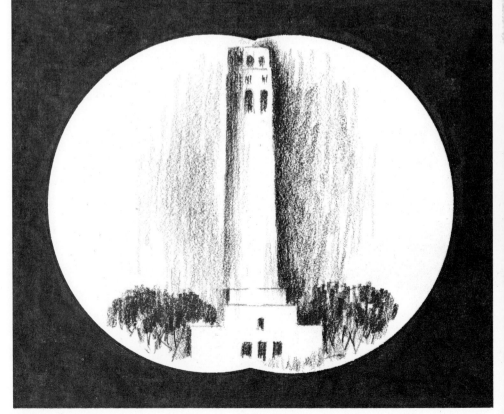

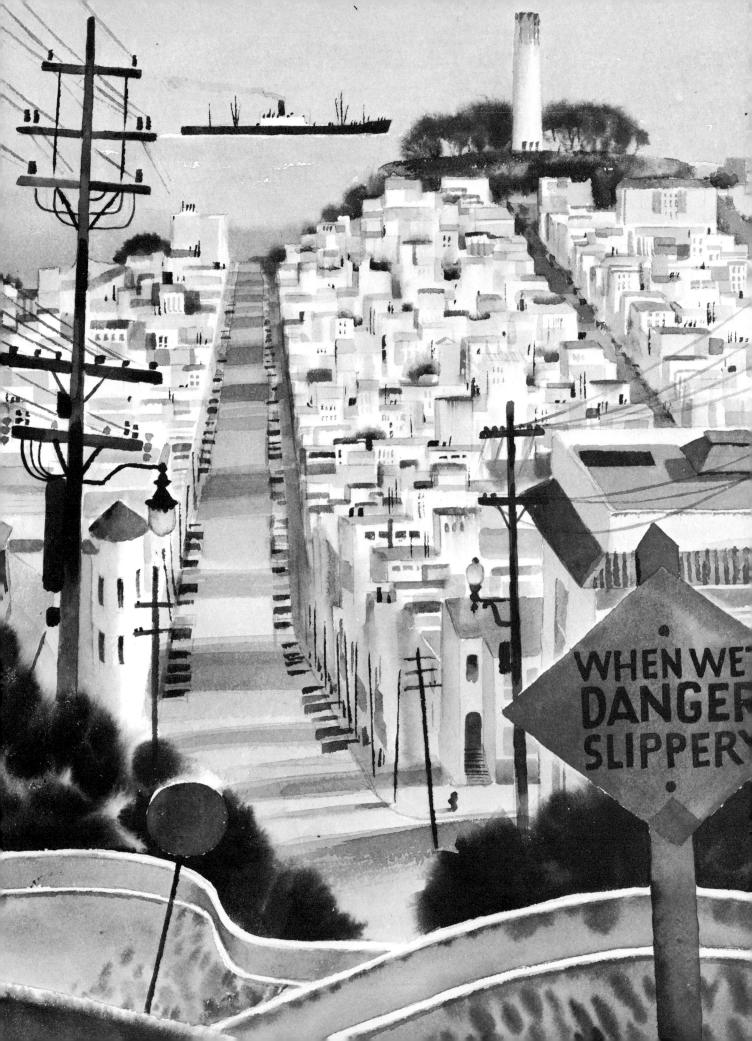

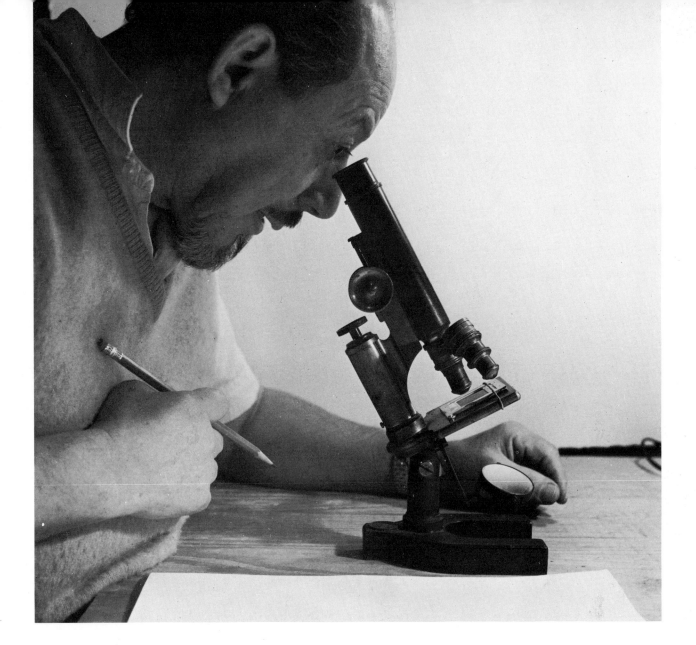

THIS SIDE
TOWARD SCREEN

Color
TRANSPARENCY

On the facing page, the complete painting, called *The Coit Tower*.

I made numerous sketches from 35mm. slides like the one shown. These slides allow you to pick out very interesting details you would not see otherwise.

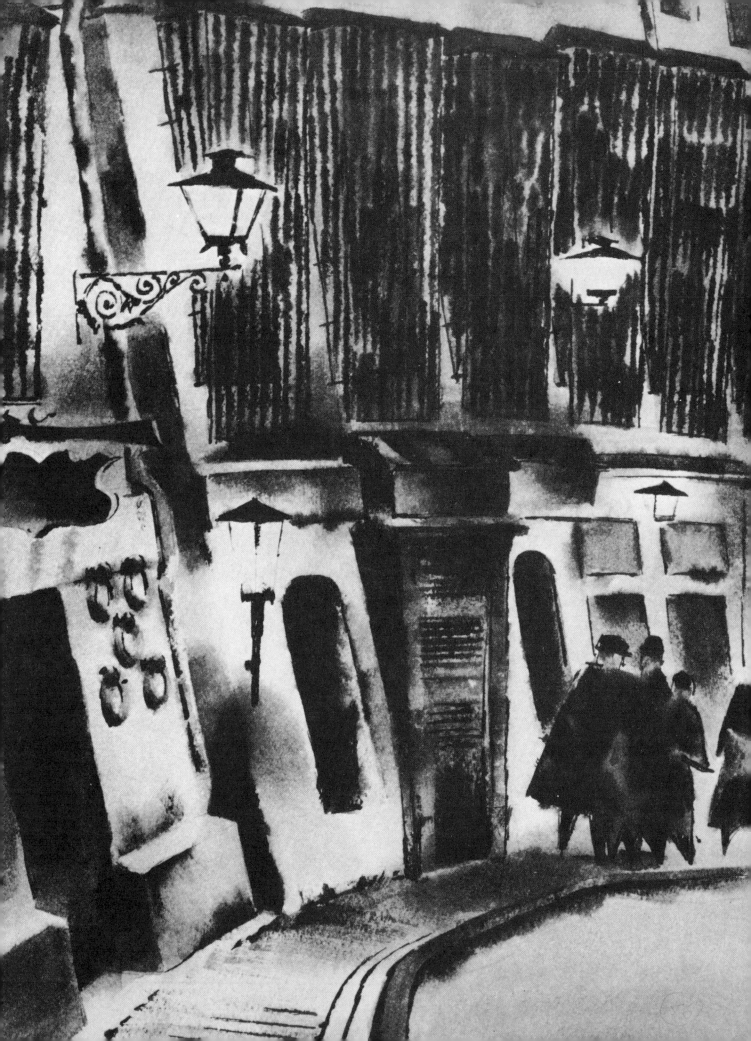

What does this statement mean: Unless you can paint a purple cow, you cannot be an artist. Very simply, it means that the good painter is one who allows his imagination full rein. There is no reason or particular merit to merely taking what the eye sees and transferring it line for line onto paper. A camera can do that better than even the best draftsman. What makes a great painting great is that special insight that an artist brings to what he sees; how he interprets a scene is more important than how the scene actually looks.

You must be able to *see* your painting rather than read it. Most of Monet's paintings, for example, become lovely abstracts when turned upside down. Indeed, almost any great work of art depends on its abstract qualities as its backbone.

My first thumbnail sketch for a painting is always a little abstraction. This enables me to simplify to the fewest abstract shapes and to reduce the values to their simplest forms, such as what is white, what is gray, and what is black. How abstract the final product remains is a matter of personal taste. But I know that good abstract composition and design must exist if you are to create a strong painting.

Two painters you might study for design are Paul Klee and Josef Albers. Both have taken an intellectual approach to art and have reduced the necessary elements of composition to their simplest, most visible components.

Taste is one of the most important aspects of a painter's vision. Most people possess reasonably good taste. It shows in their selection of clothing and furniture. Yet these same people are sometimes not conscious of — or do not think to use — their taste when it comes to art.

Don't ever try to force colors or designs on yourself that you don't really like.

Texture is also an important element. A matte texture, for example, will keep the color constant. Imagine a bottle being covered with a cloth — say, red. The color red will change very little from left to right with ordinary lighting. Imagine that color red as it looks in a glass or metallic texture. The color will no longer retain its consistency — it will "explode," and take on the full range of the color triangle. It will have tints, shades, tones, and hues. The one or more highlights will be reflecting the source of light — a window or a lamp. The highlight will appear to be whiter than white.

The constant red is no longer there. What has happened is that the bottle has become a red glass mirror. In other words, light transforms the red hue of the bottle into areas of white through a series of tints. At the same time, other areas go from hue toward red-black through a series of shades. Each hue has the potential value range from white to black. Texture is the controlling factor of the potential of the hue. Texture determines how light or dark a color will get within its given area. With a matte texture, the color will remain more constant. With a surface that has a luster or high polish, the color will rise to light and fall to dark. See the color triangles on page 66 for the representation of these principles.

So much of what an artist records on paper is a result of direct observation of the world around him. Light and shade, color, the little nuances of design — nature has already painted them all, much better than the human hand could ever do it. Yet, most people don't know how to see these things. A good painter trains his eye to record those details that will give his paintings a more real, more lifelike quality. In many cases, this ability is based on intuition, but almost anyone can improve his powers of observation.

Facing page, *Cuchilleros Street.* Many sketches and the study of dozens of 35mm. slides such as the one on the previous page preceded the final painting of this old street in Madrid.

A sawtooth design at the top; three vertical lines on the left that make the letter "N"; two parallel verticals on the right; and a diamond in the center —this combination of abstract patterns could be left just as it is.

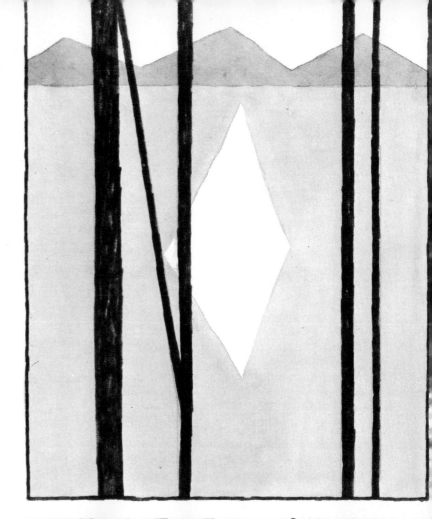

The abstraction has become a more personalized design.

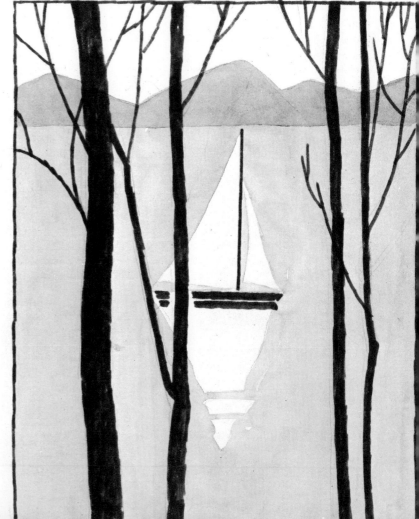

Again, stark and simple abstract lines stand on their own.

However, if you are like me, you will want to build on the abstraction and make it work for you. Study Monet—that's what he did, too.

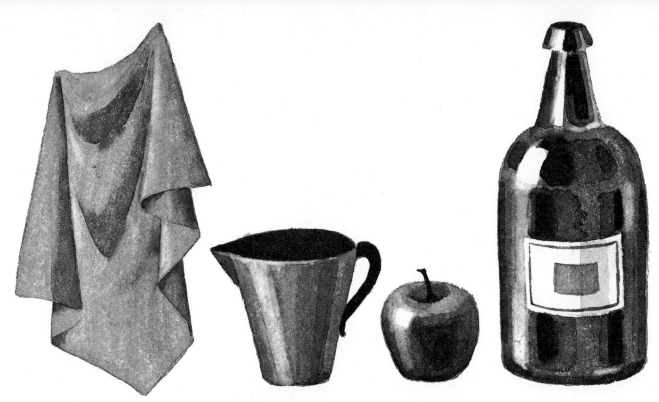

Examples of various textures. The cloth at the left has a matte texture; the pewter, a sheen; the apple, a gloss; and the bottle glitters with highlights.

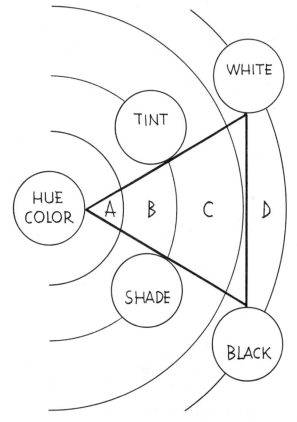

How far a color will go into white, gray, or black depends on its texture. Matte will not go very far—just to "A"; sheen goes a little further—to "B," gloss even further—to "C," and glitter reaches "D."

The potential of any color hue is represented in this color triangle, which shows seven classifications. A color can get very dark *(shade),* very light *(tint),* and very gray *(tone),* and this scheme applies to all colors.

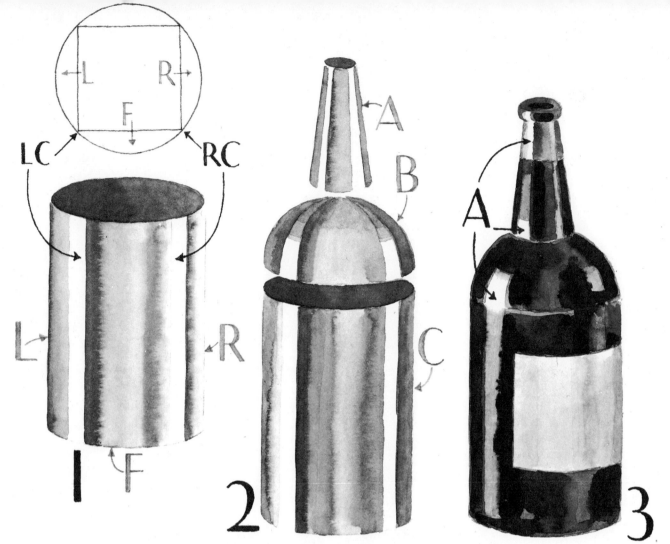

We see three planes or faces of most objects, but with a cylinder, we see four—left, front, right, and top. In any form, where one plane turns into another, you will get a highlight that sometimes is accompanied by a dark. The bottle you see in No. 2 has been reduced to its basic geometric components: A, B, and C; and in No. 3, where the cylinder meets the hemisphere, and then where it meets the cone, highlights appear.

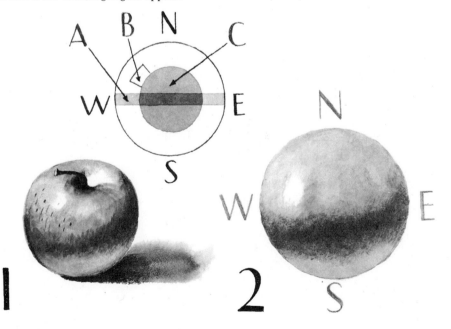

If you think of a spherical object as a globe, it will be easier to paint. As the diagram shows, the sphere can be seen as having a north, south, east, and west, as well as an equator that encircles the sphere and is usually a little darker than the rest of the color (A). In addition, the sphere has a front face (C), and highlights (B) occur as the front face turns in the Northern Hemisphere.

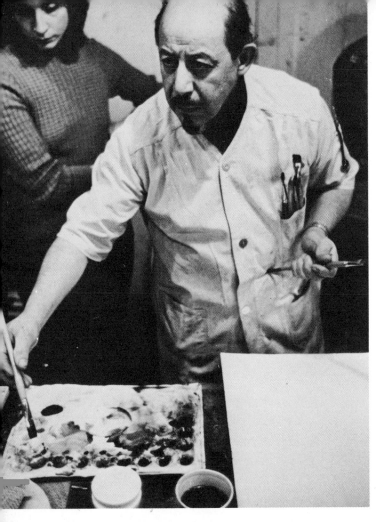
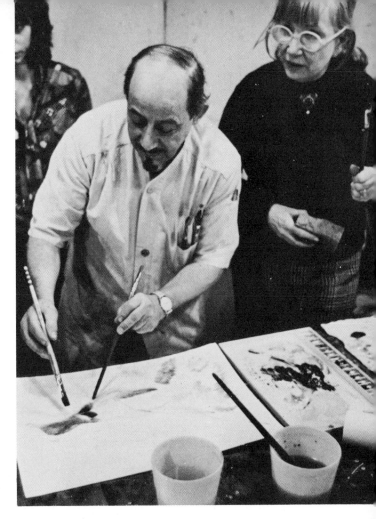
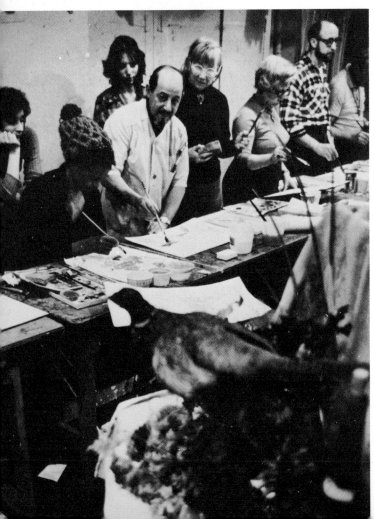
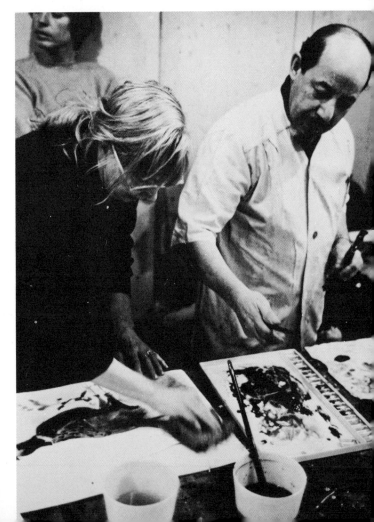

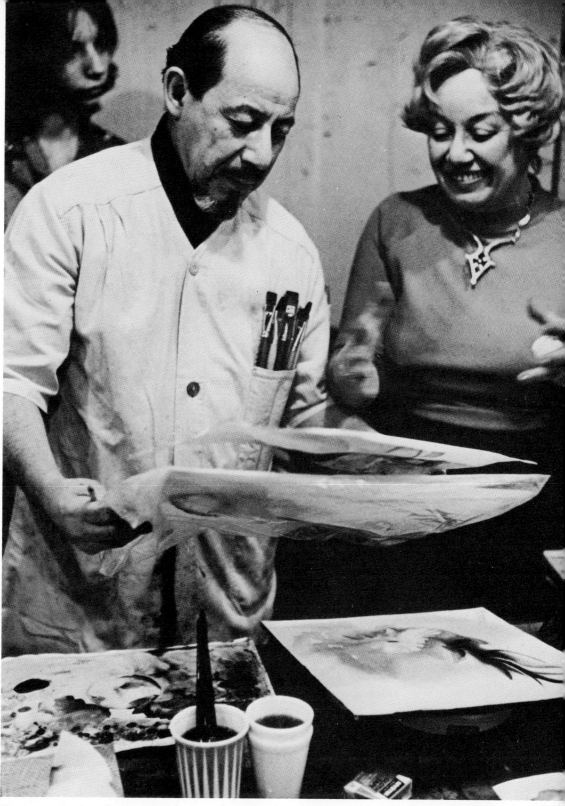

Demonstration in a class at the New York Art Students League. One of the photos at left shows
a student taking out a painted area with a sponge. Above, a student smiles as I praise her painting.

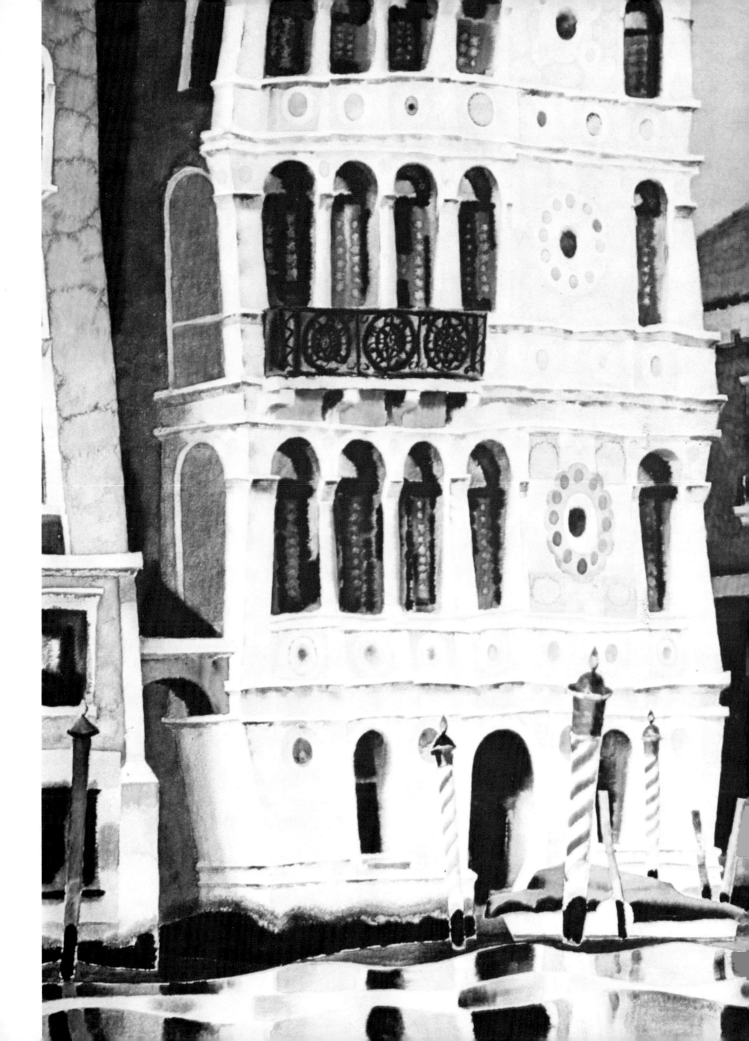

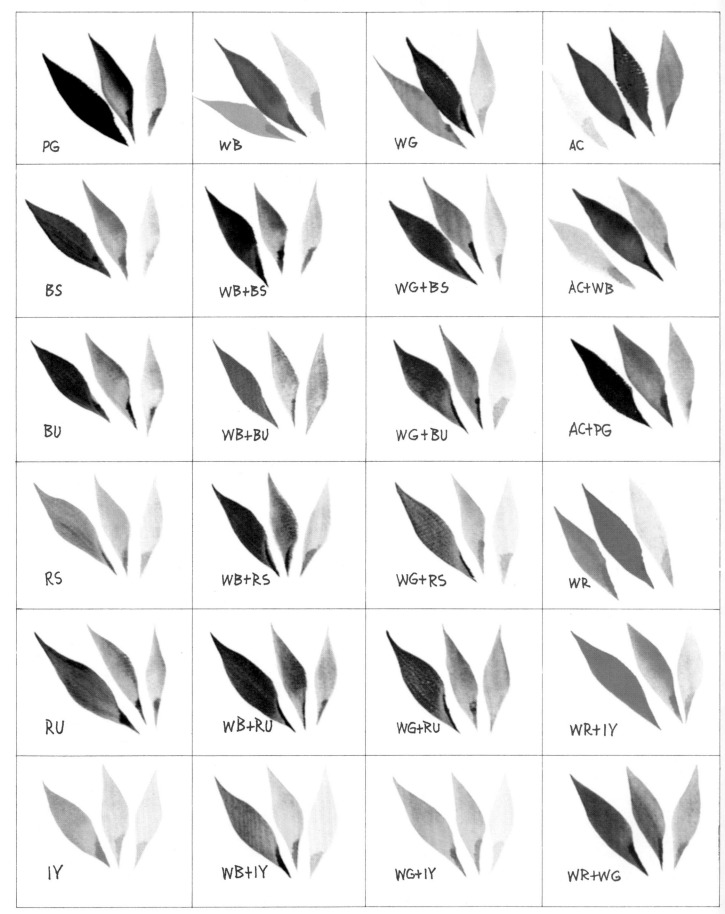

In this color combination chart, I've used initials for the colors, such as IY for Indian yellow, WB for Winsor blue, and so on.

Previous page, *Palazzo Dario*. This was a prize winner in the 103rd American Watercolor Society's Annual.

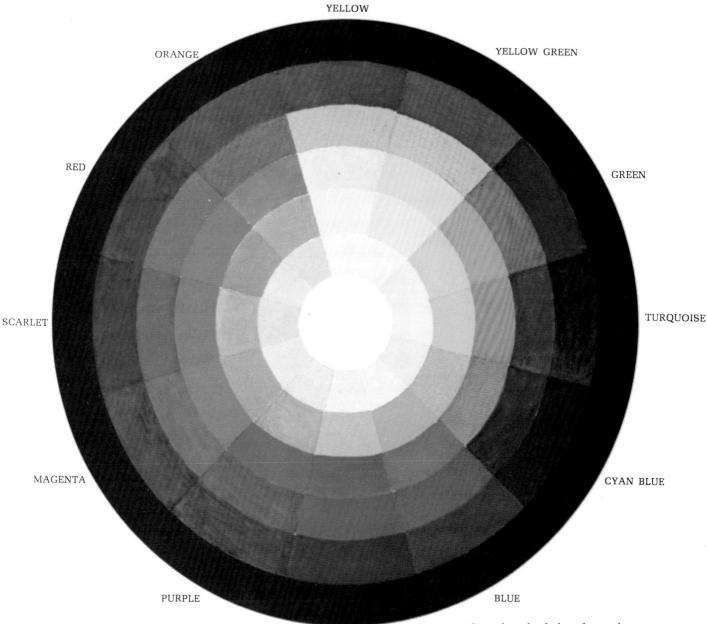

YELLOW

ORANGE YELLOW GREEN

RED GREEN

SCARLET TURQUOISE

MAGENTA CYAN BLUE

PURPLE BLUE

VIOLET

This color wheel, though greatly
simplified, gives you the main colors
with their tints, shades, and black
and white.

TRIADIC COMPLEMENTARY ANALOGOUS

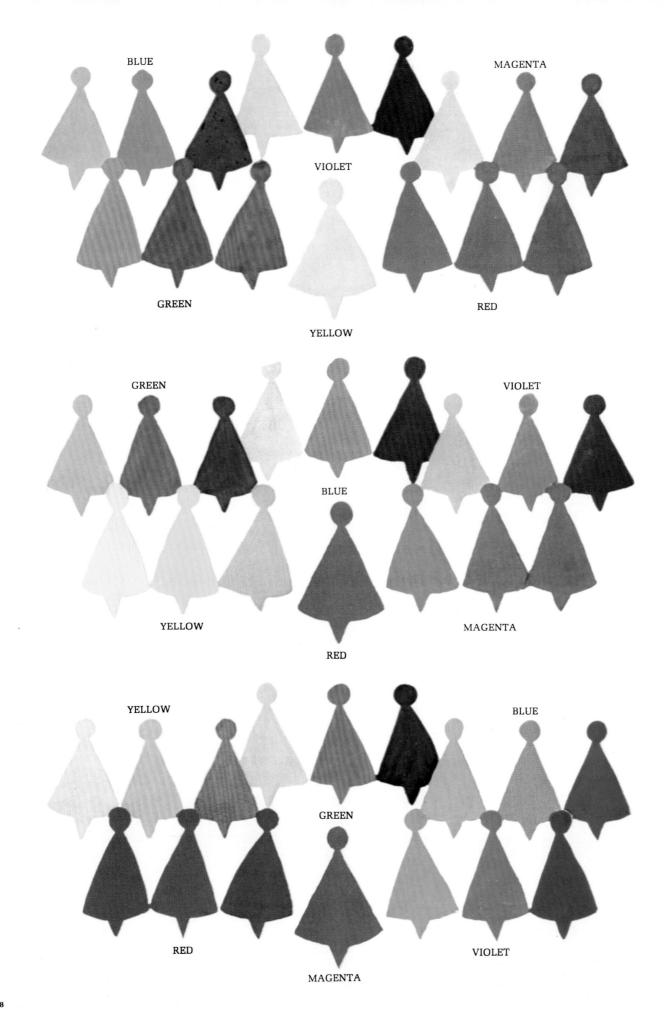

BLUE

MAGENTA

VIOLET

GREEN

RED

YELLOW

GREEN

VIOLET

BLUE

YELLOW

MAGENTA

RED

YELLOW

BLUE

GREEN

RED

VIOLET

MAGENTA

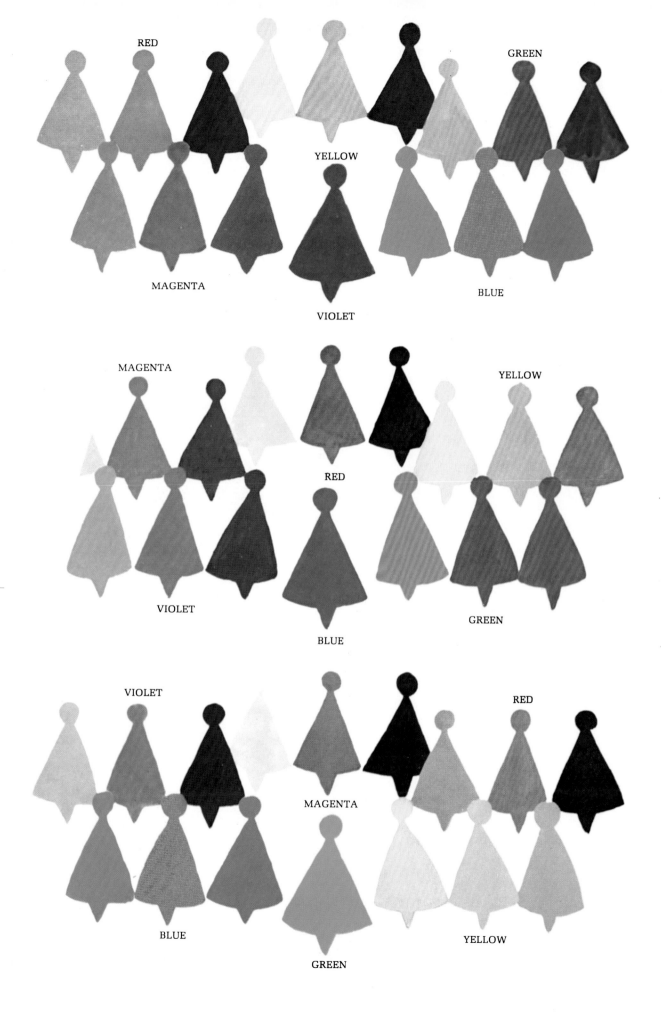

RED

YELLOW

GREEN

MAGENTA

BLUE

VIOLET

MAGENTA

YELLOW

RED

VIOLET

GREEN

BLUE

VIOLET

RED

MAGENTA

BLUE

YELLOW

GREEN

The sketch at the upper right is a dynamic rendition of the Peace Memorial of Hiroshima. I executed it on the spot, while surrounded by a group of Japanese schoolgirls who were doing the same. The 35 mm. slide of the Memorial is at left, and below, a painting of the same subject.

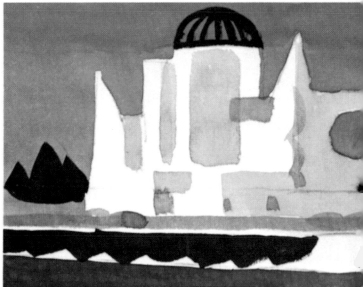

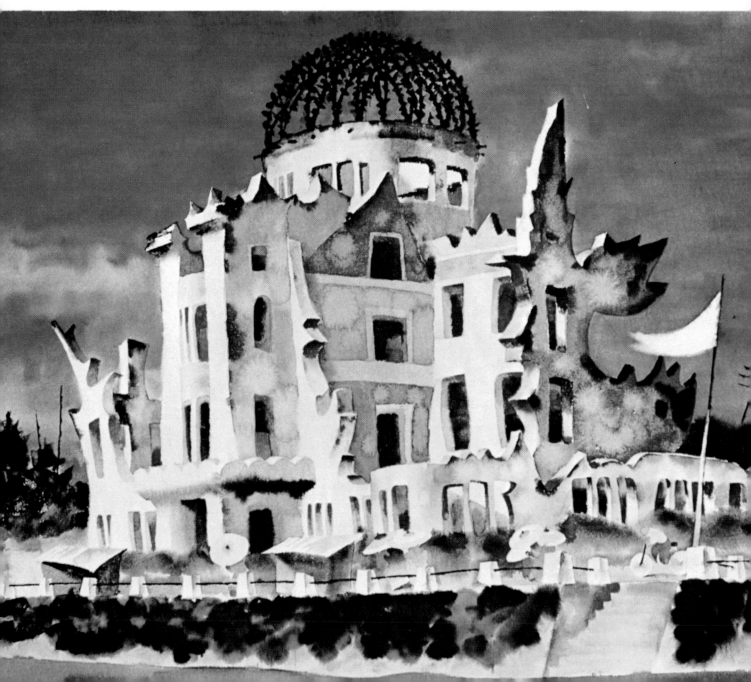

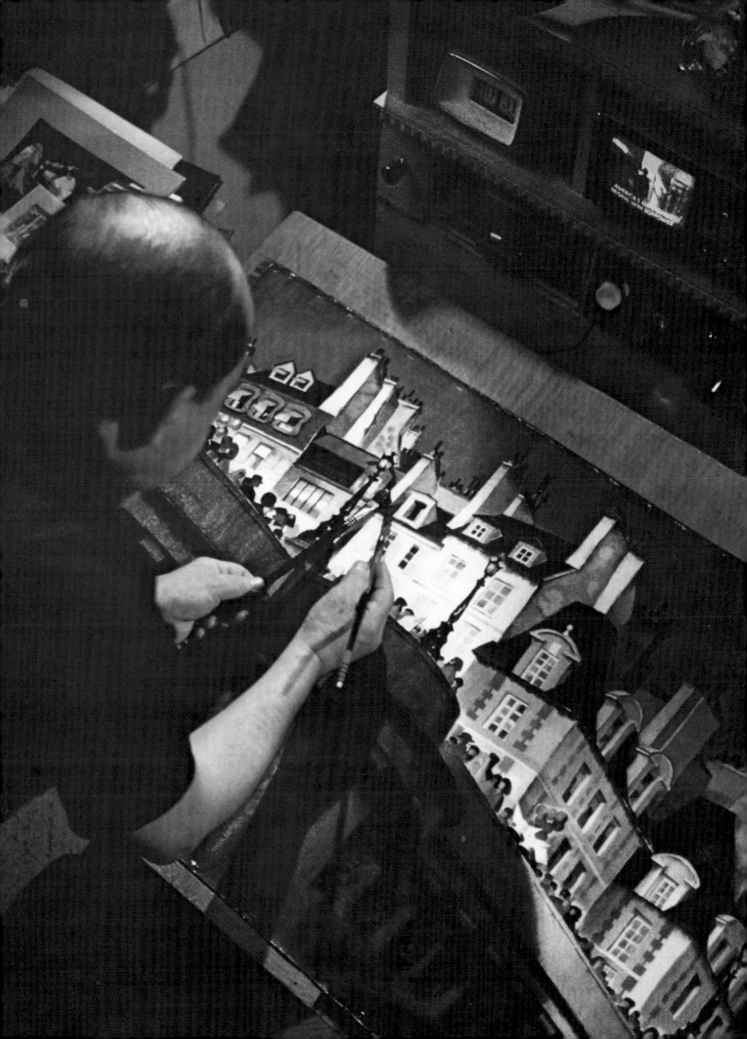

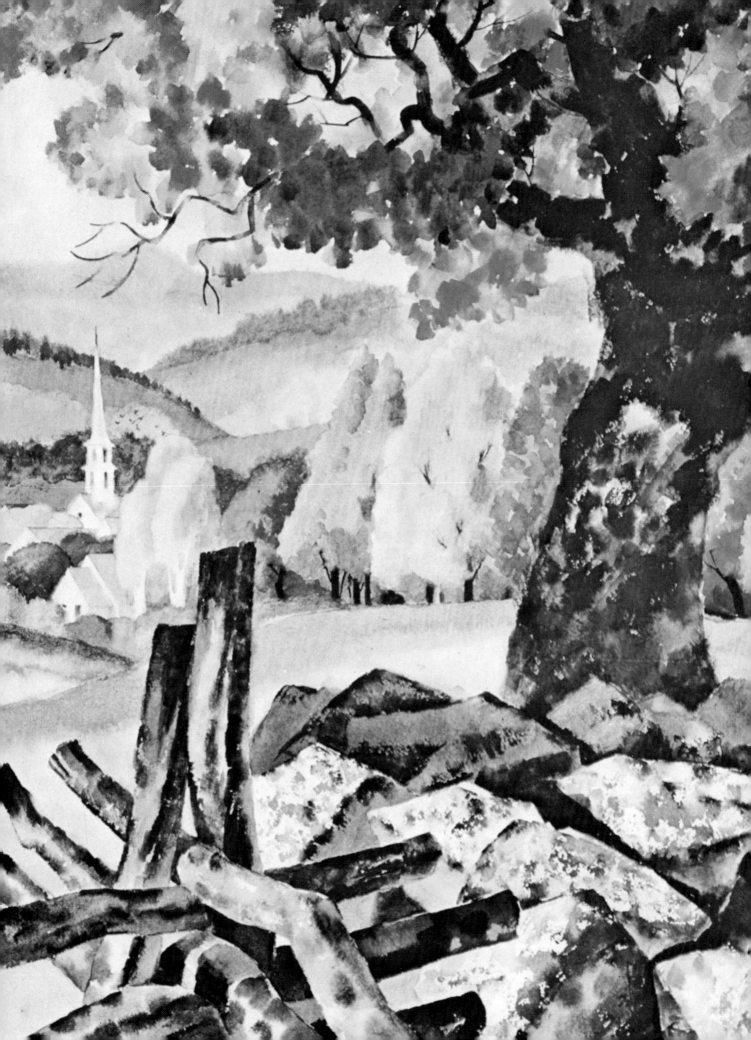

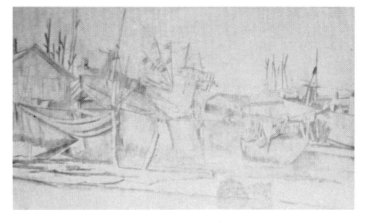

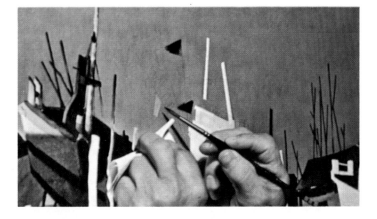
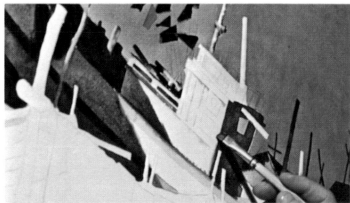

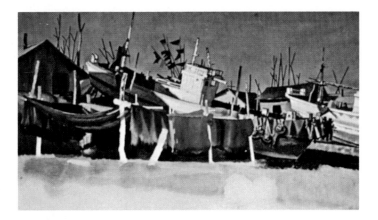
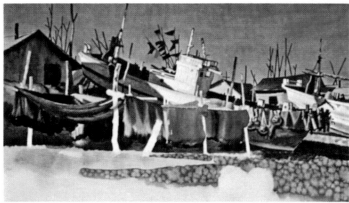

Page 72, sketch of Central Park in New York City, with the Dakota Apartments in the background.

Page 73, in *New England*, painted especially for this book, note the different textures of rocks, posts, bark, foliage, hills, and buildings.

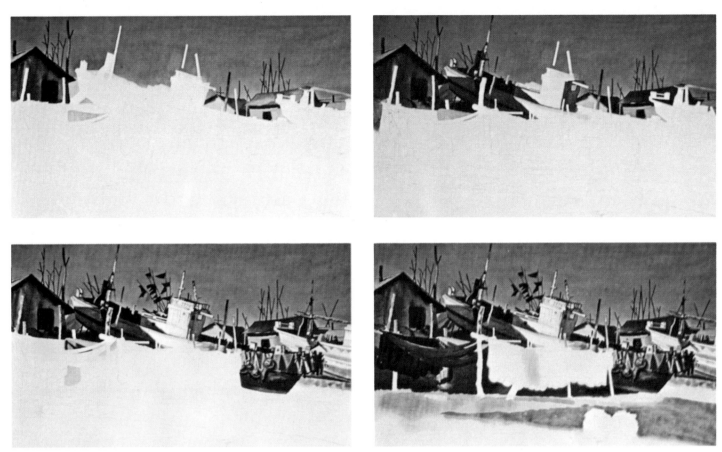

Hokkaido Fishing Village. Various progressive stages and details of this winner of the 104th American Watercolor Society's Annual are shown.

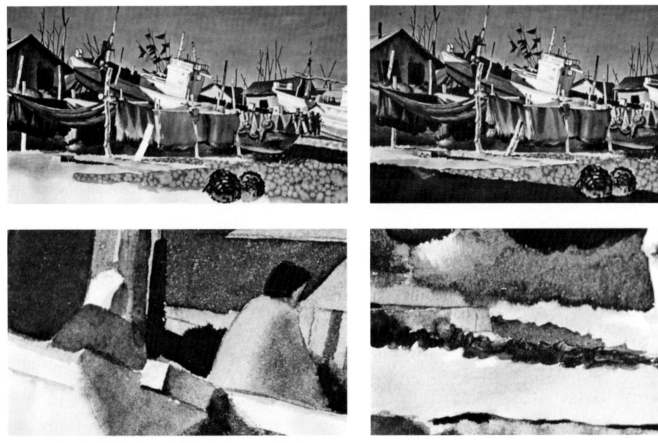

Next page, *Pont Neuf.* Painted on a half-sheet of 140-pound Arches.

Page 78, *Sunday Morning—Manila.* Award winner in the 89th American Watercolor Society's Annual, this picture was painted on 300- pound Arches Imperial.

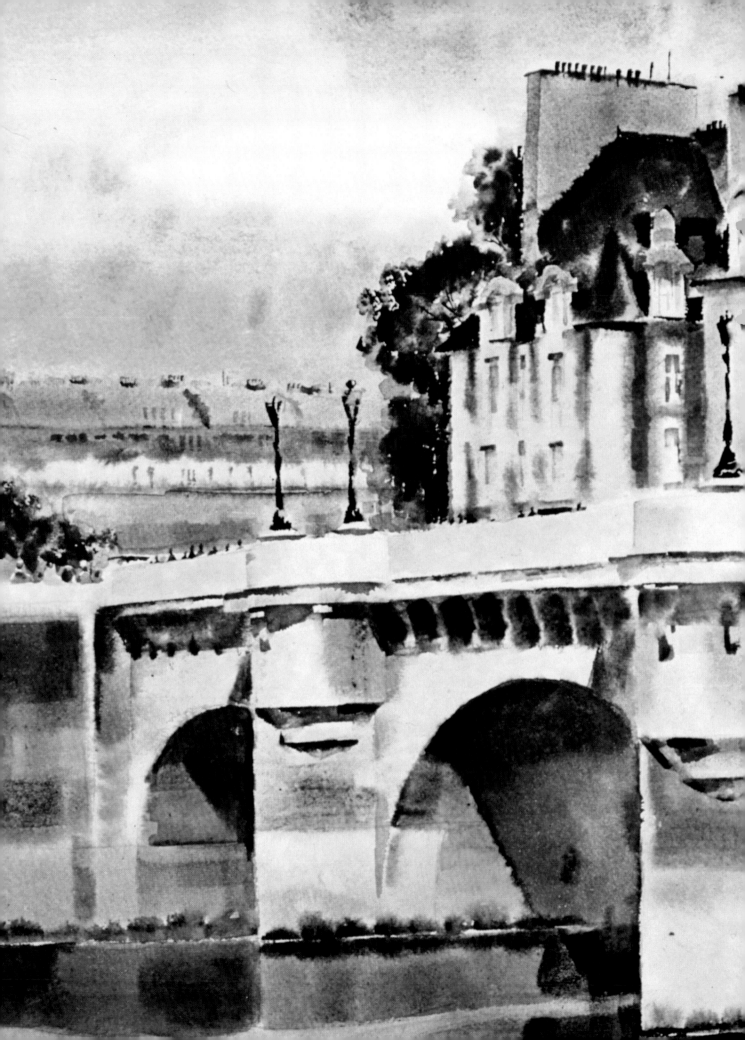

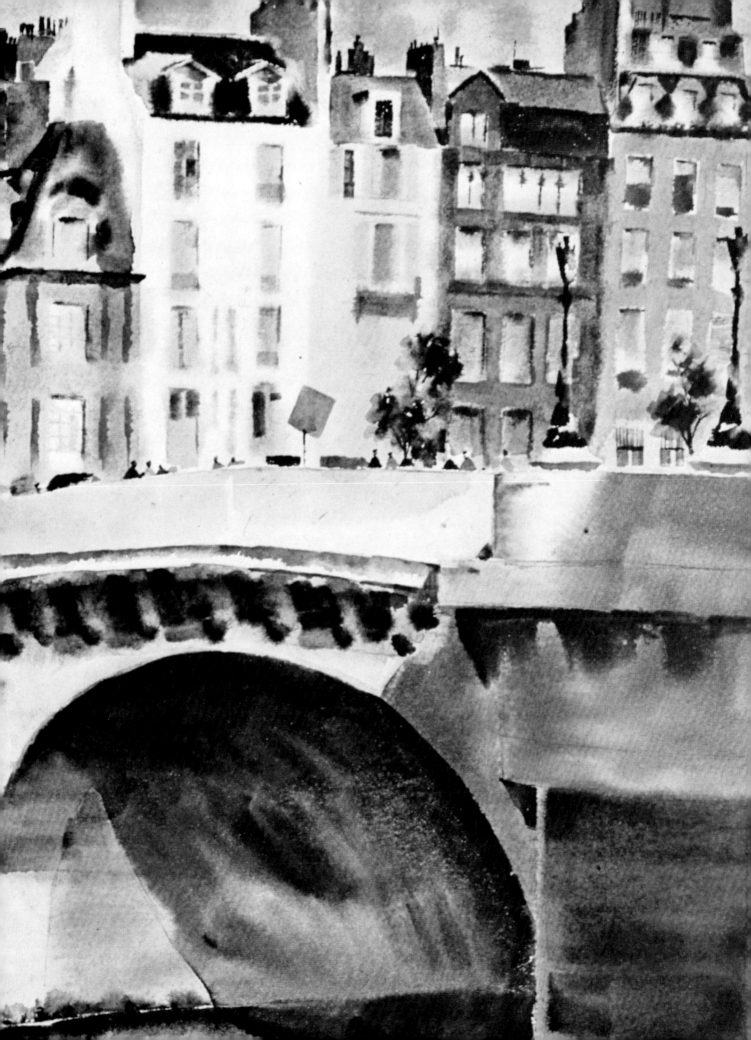

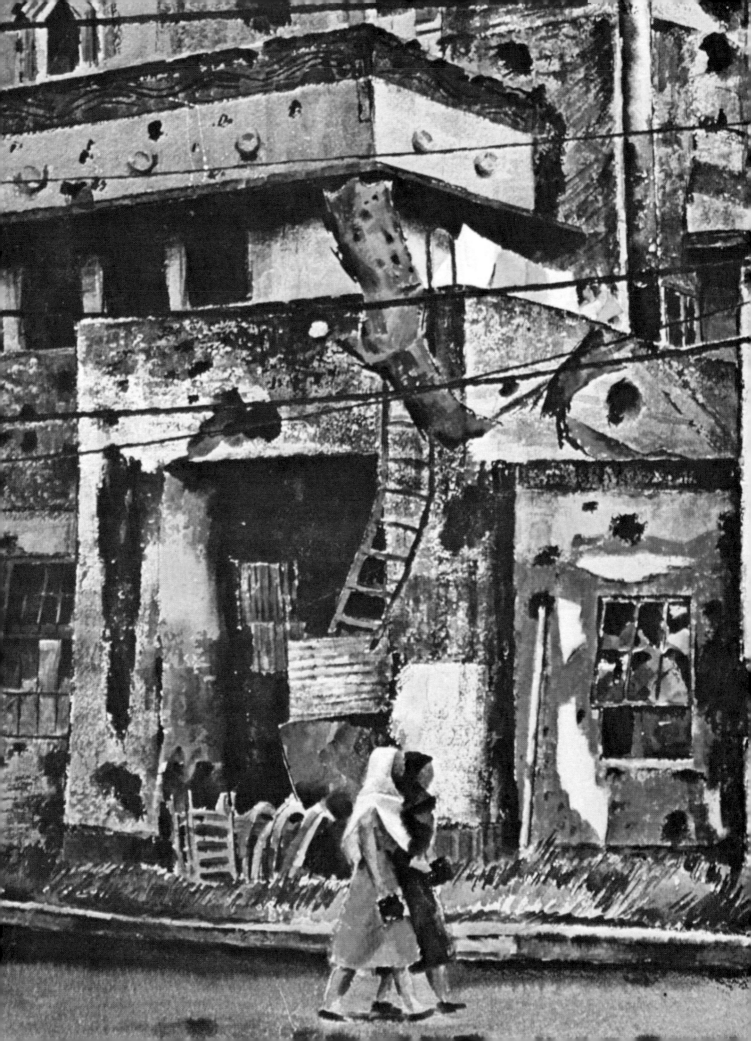

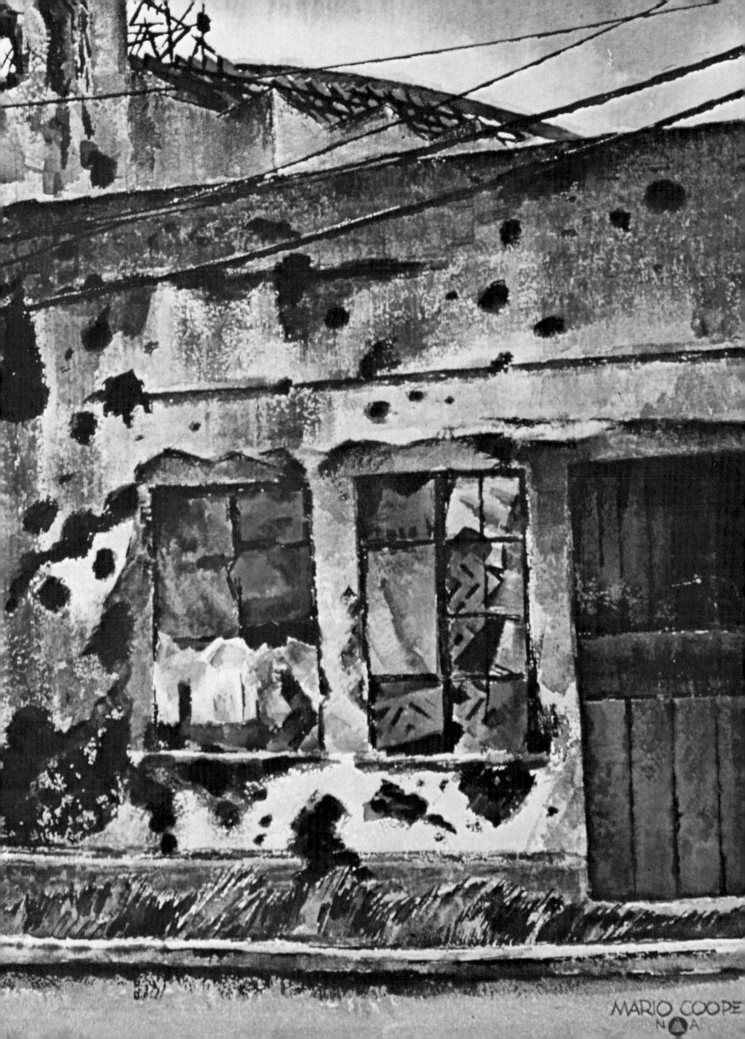

MARIO COOPER
N A

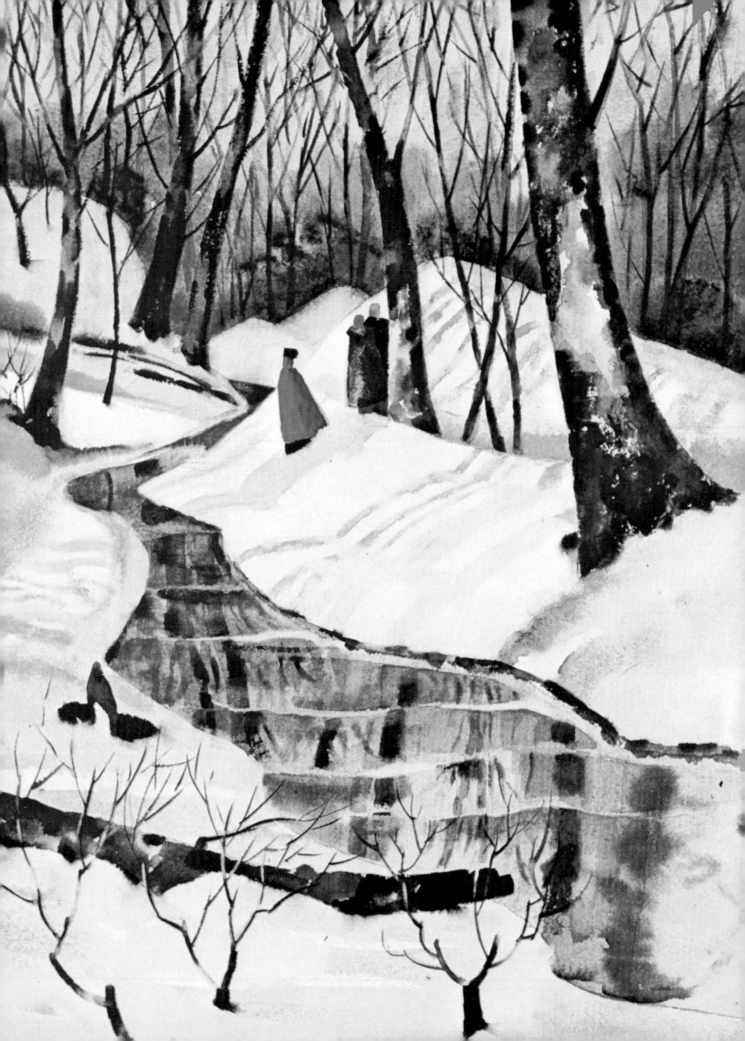

Composing abstract designs for paintings can be very exciting and will keep you flexible. The four here are, from top to bottom: a sketch for the Piazzetta di San Marco in Venice; a sketch for *Hokkaido Fishing Village,* in Japan; a sketch for *Castel Sant'Angelo;* and one for *8 a.m. at the Rialto.*

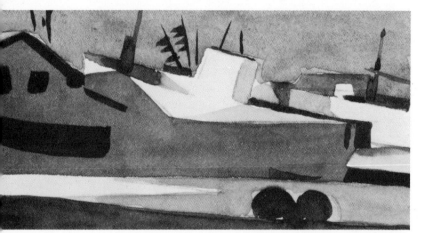

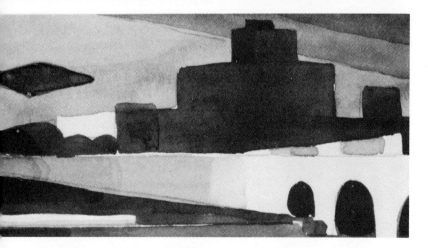

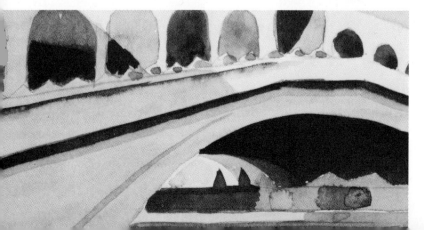

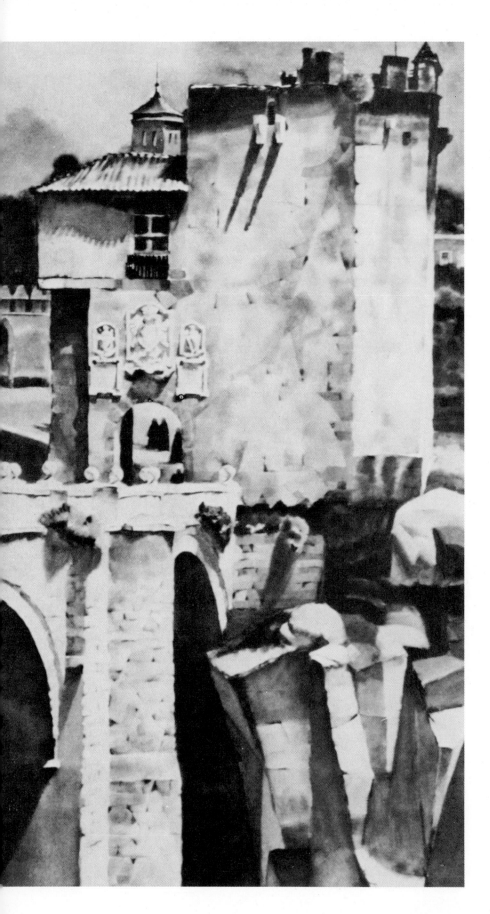

At left, *St. Martin's Gate, Toledo.*
Painted on Double Elephant 200-pound
Fabriano, the picture was an award
winner in the 101st American Water-
color Society's Annual.

Study the abstract quality of the details
on page 83, such as the strong emphasis
of patterns and simplified handling of
the coat of arms. The imagery in a de-
tail of the wall is particularly nice.

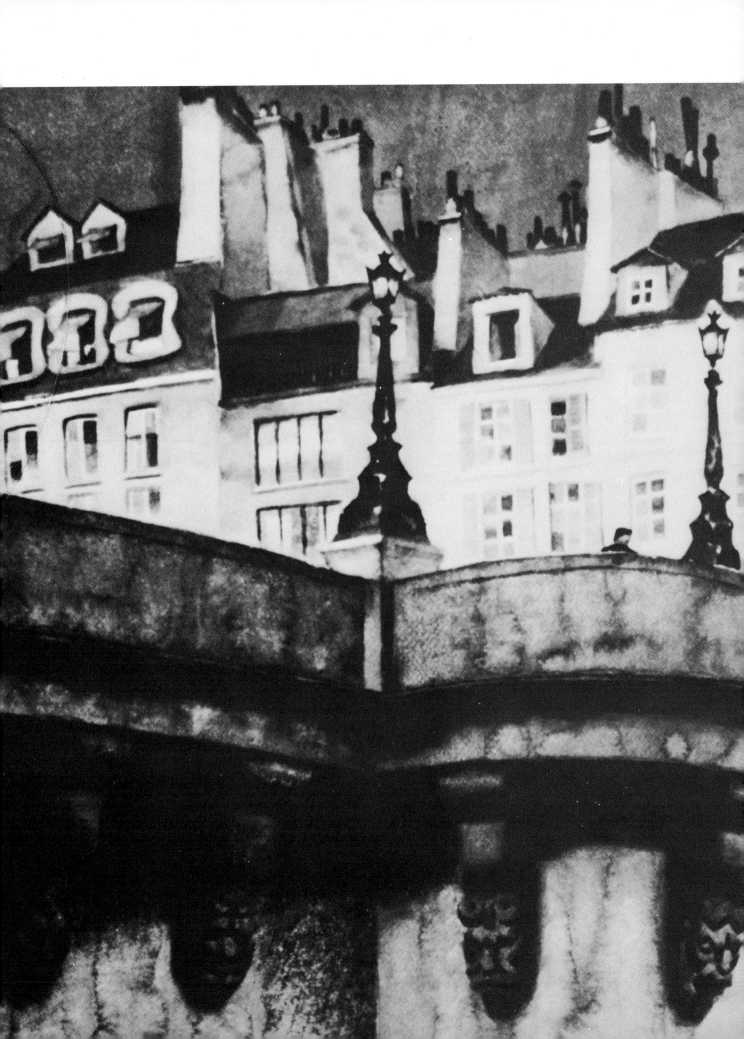

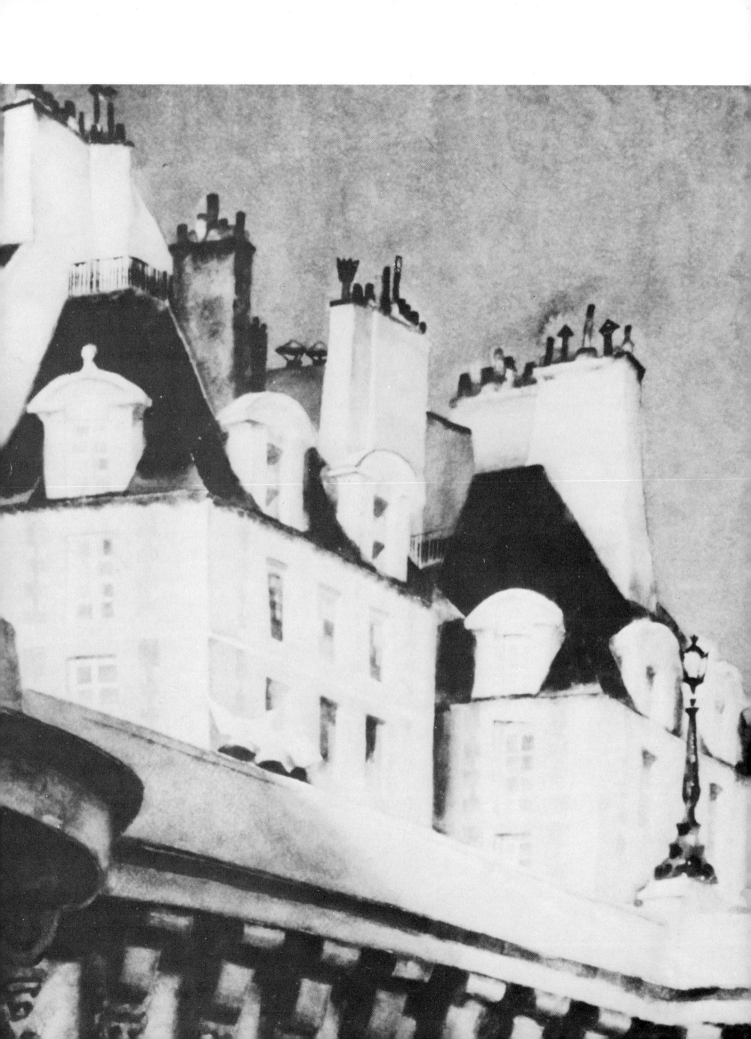

Page 71, I am adding some touches to *Pont Neuf*, some progressive steps of which appear below. A lot of people on the bridge seemed like a good idea at first, so to try it out, I tore color pages from a magazine and proceeded to cut figurelike shapes out of them and place them in position. It still seemed a good idea, so I painted the figures in the colors I wanted on a thin piece of watercolor paper, cut out the group, and placed them in position. Since they looked all right, I then painted them. Later, when I decided they made the painting look too busy, I carefully took them out, using first a sponge and then, after the paper was dry, continuing to take out the balance with an ink eraser. How *Pont Neuf* looked when it was finally exhibited is shown on the previous two pages.

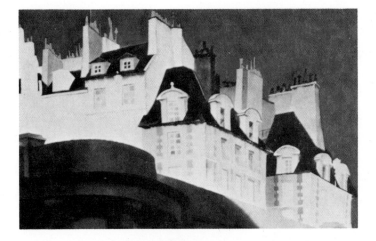
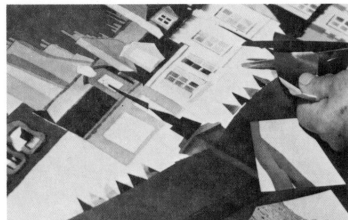

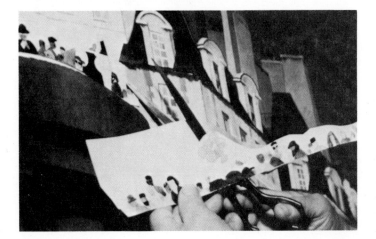
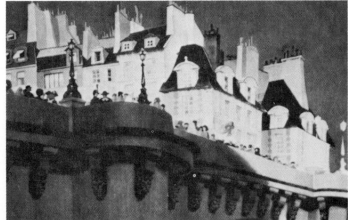

Landscape painting requires the same fundamentals that are needed for painting a nude, flowers, or a still life. In all those areas, the basics are always color, composition, and design. However, every subject has its pitfalls and so does landscape painting.

In a landscape with trees and a horizon, the most common error is that the trees are placed too close to the edge of the picture, practically making a frame. A psychiatrist could possibly give you a good reason for this. My own is that the painter is either scared to put the trees in or he is apologizing for them. You should be positive about such things — even when wrong.

Often, a beginner will have difficulty painting a tree trunk. Usually, it comes off flat in both form and color. A trunk of a tree and its branches should be alive and the way to accomplish that is to go from one end of the value scale to the other. If you notice trees in winter, you will see that you can tell the position of the branches and trunks by the changes in their light value. A branch facing the source of light is, obviously, very light; the one paralleling the source of light is gray; and the area opposite the light source is black. This adds dimension as well as color to the tree. Once again, it is a case of observing how things around you really look and can contribute to your painting.

Local color is a common approach that is represented, for instance, by a sky that is painted all in one color without using the color of its neighbors — like the color of mountains or trees or the general terrain of the landscape. In other words, painting a mountain all one purple, painting the sky all one blue, and painting a tree all one green is not advisable unless you have a good reason.

Another danger is getting a monotonous color within each larger element of the landscape. For example, the sky is going to be blue usually. But mentally divide your sky into three sections and paint the left side a warm blue — almost a purple — and have the middle part carry the main color, which will be a blue such as French ultramarine. Then paint the right side with a cold blue, like cobalt or cerulean, and add just a touch of green. The sky will read blue, but it won't be monotonous in color.

As to how to paint it, first mix the different colors of blue in separate containers. (A plastic container that is used for making ice cubes in the refrigerator is excellent for this purpose.) Mix each of the colors and then test them on a separate piece of paper and have them all ready to use so that you can attain a fusion of colors without any separations. And you don't have to clean the brush each time you change to another color since the color that is retained in the brush will help the fusion of the colors. This system can be applied to almost anything — trees, water, and human figures.

Mountains in the distance can become simple silhouettes, dark or light. However, as you paint them closer they become an interesting geometric design. They are usually very prismatic in their texture. This, in combination with sections of cubes and polyhedral forms, gives you a symphony of tetragons, octagons, and polygons.

Foothills, on the other hand, are less angular and run more toward spherical forms — concave and convex forms. Some hills or groups of hills almost take on the character of a reclining female figure. So mountains become simple silhouettes or a series of jagged lines or brittle surfaces and hills become lyrical curving lines and rolling forms.

One thing should be understood. Snow is white. So when you start with a piece of watercolor paper, you've already got a snow scene. But here again — since you are making a composition—it has to be a symphony in white. It can be a blue white, yellow white, red white, and so on. Blue white occurs where the snow turns from light into shadow, but as it starts to go into the shadow it is frustrated by reflected light from, perhaps, an opposing bank or its equivalent, which flashes back a yellowish or orange light. Using this natural phenomenon can keep your landscape from looking dead.

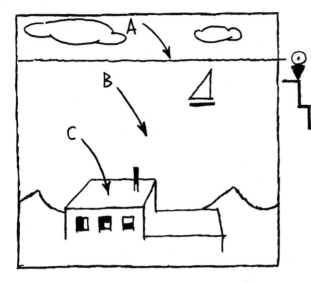

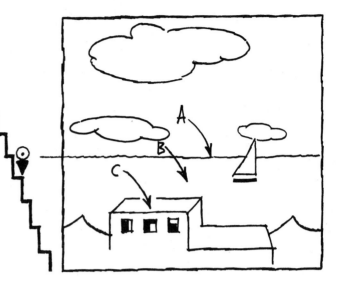

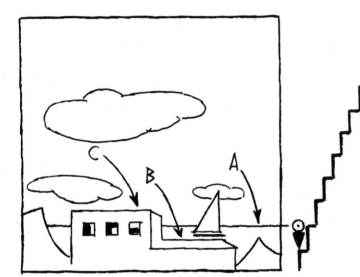

Remember that the horizon line is where your eye is. To demonstrate this, look at the ladder between the two diagrams above. Assuming that the black triangle with the circle is you, when you are on the top step, the horizon is where your eye is (A); you are also looking down on the water (B); and down on the roof of the beach house (C). When you descend the stairs, you take the horizon line down with you. At left, you've reached the bottom step. You no longer look down on the rooftop. You can see a little of the deck, a lot of sky, and very little of the water.

The bottom-left diagram on the next page depicts some of the common errors in landscape painting: trees too close to the edge (B and D); branches parting at the same spot (A); the trunk one thickness throughout; and the horizon right in the middle. Next to this exercise in symmetrical boredom, you see a more interesting treatment of the subject. Here, the trees are well into the picture; the branches ascend from different points on the tree; and the horizon is lower, making for a better proportion. See to what extent this more vital approach has been used in the painting of Central Park.

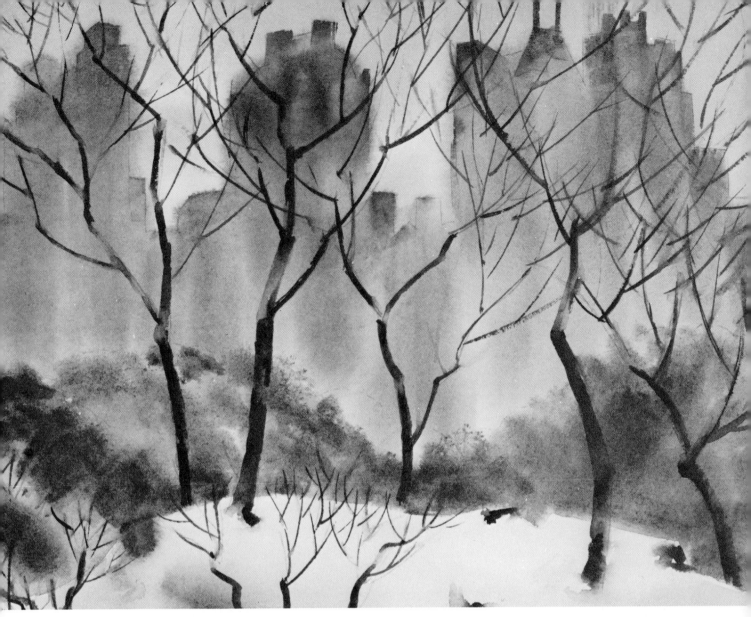

This painting of Central Park shows leafless branches making a lace-like pattern across the sky.

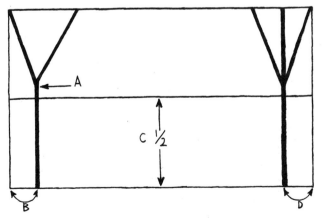

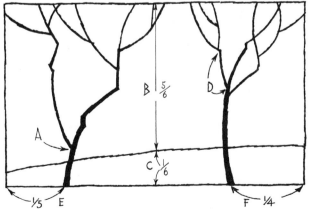

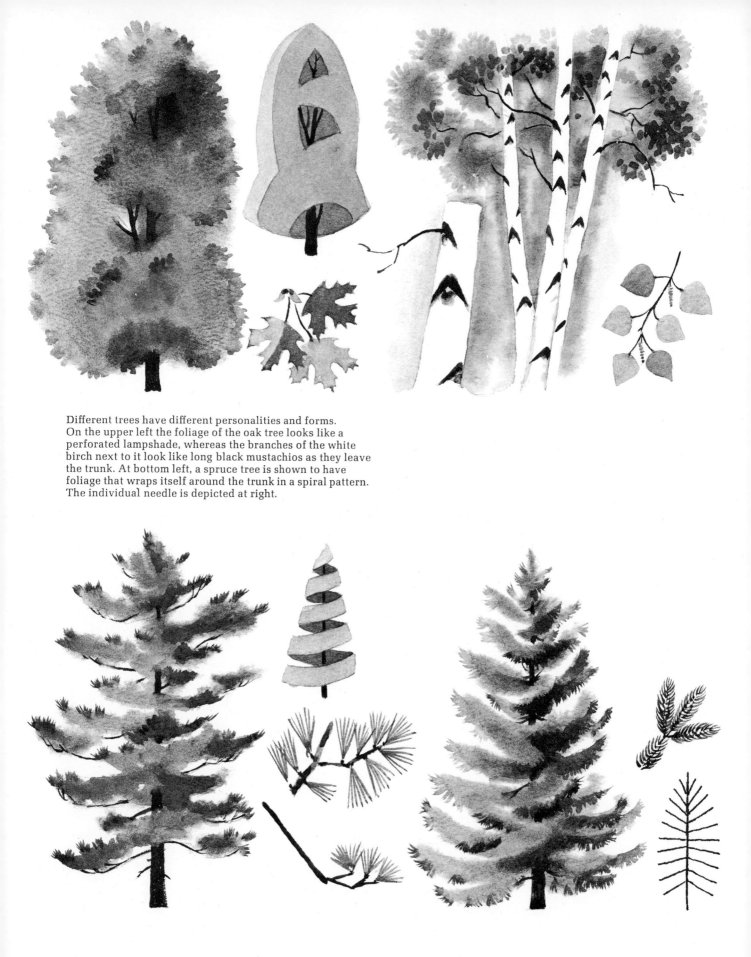

Different trees have different personalities and forms.
On the upper left the foliage of the oak tree looks like a
perforated lampshade, whereas the branches of the white
birch next to it look like long black mustachios as they leave
the trunk. At bottom left, a spruce tree is shown to have
foliage that wraps itself around the trunk in a spiral pattern.
The individual needle is depicted at right.

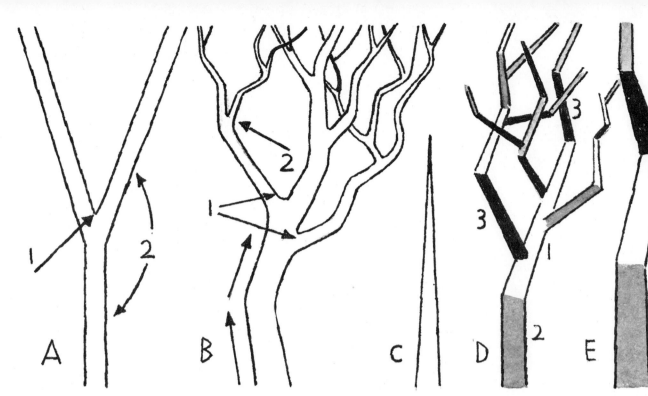

Diagram A depicts the same error mentioned on page 81 and in Diagram B, you can see how to vary the starting points of the branches (1-2), and change the direction of the trunk (B). Most trunks of trees, like rivers, go from thick to thin (C). D and E show you how the angle of a branch can change its value (from 1. white, to 2. gray, to 3. black), thus giving dimension to the tree.

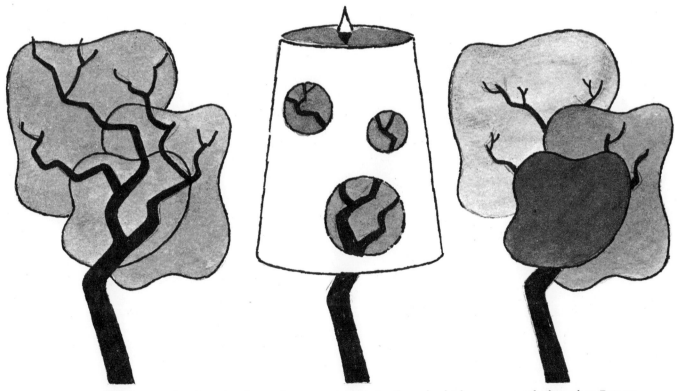

The student often makes the mistake of putting the trunk in front of the foliage; actually, trunk and branches should go *into* the foliage the way the base of a lamp goes into a lampshade—except that the lampshade (foliage) should have holes through which you can see the branches. Remember that foliage needs to be given all three values—light, shade, and dark—if you want it to have depth and variety.

It is interesting to look at the different silhouettes of trees: some are more round than others, some more triangular, and others more square. The shape of the live oak on the left is a compound of the round and triangular forms, and its branches are nervous and staccato, whereas the elm on the right is fanlike and lyrical, with flowing branches.

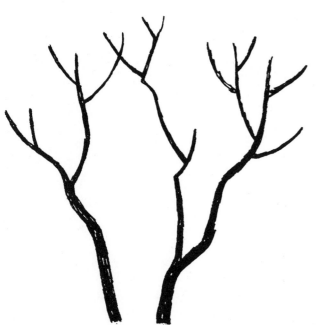

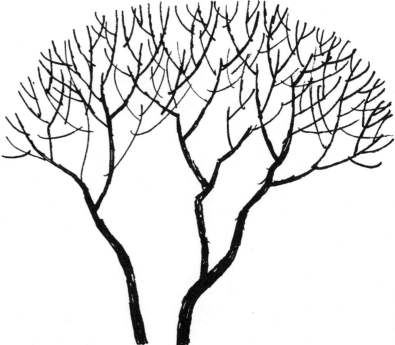

In winter scenes, don't end the branches of your trees too suddenly, giving them an aborted, pruned look. They should end by thinning out gradually, forming a graceful, fragile pattern.

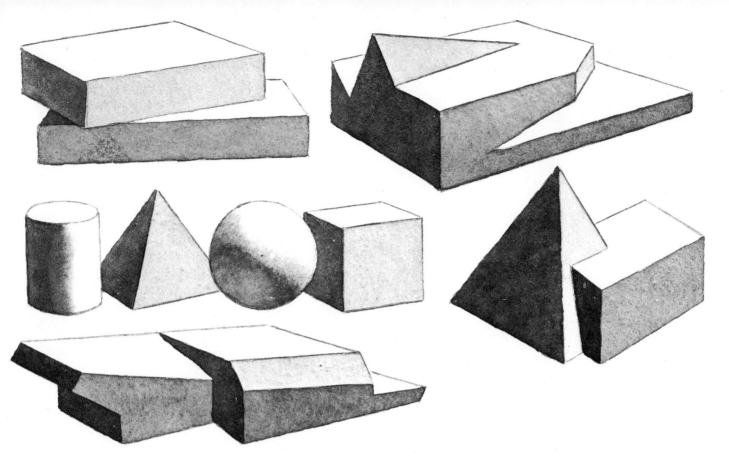

With rocks, you are dealing with solids that come in all geometric shapes. The stone wall below has rocks in the form of triangles, oblongs, and combinations of these two shapes. Emphasize the texture on the light side of the rock, and then, as the rock turns into shadow, it should flow smoothly and get darker, until it gets lighter again by virtue of reflected light.

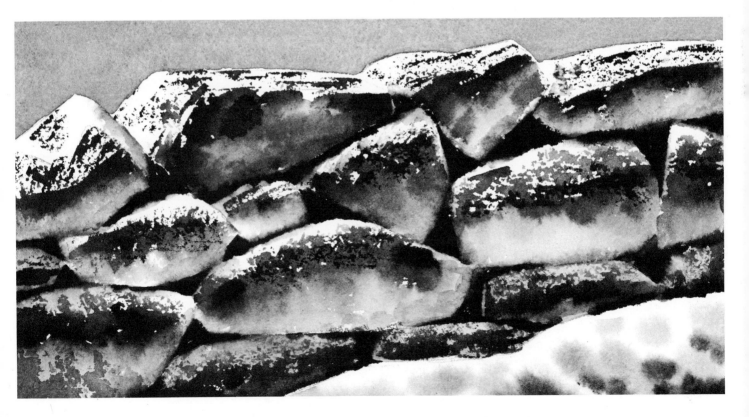

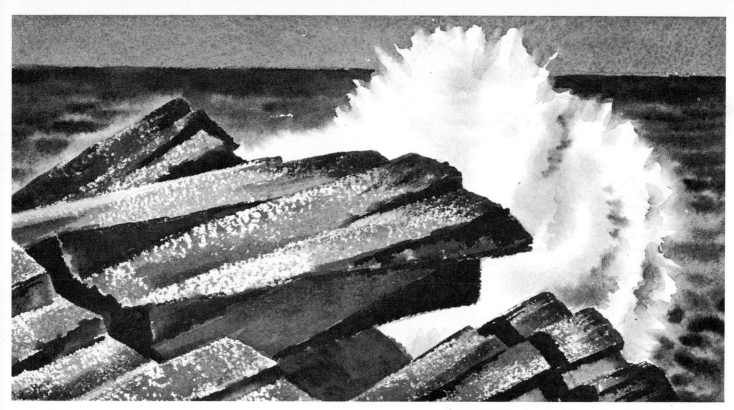

The geometric shapes of the rocks in this seascape are strikingly defined.

Rocks that have been battered and pounded by the sea like the ones below lose their angular and jagged edges eventually, and become rounder and smoother.

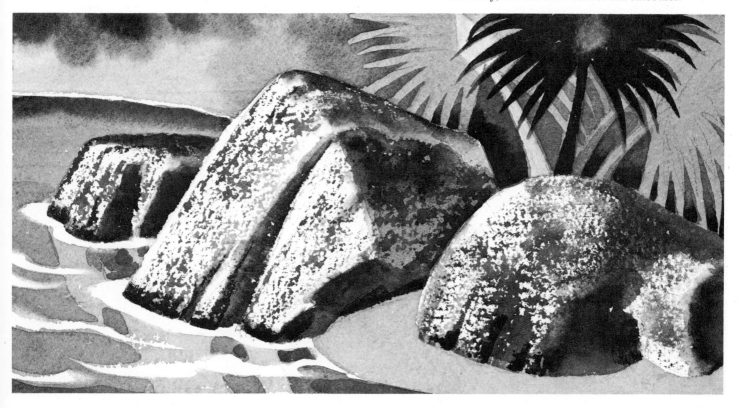

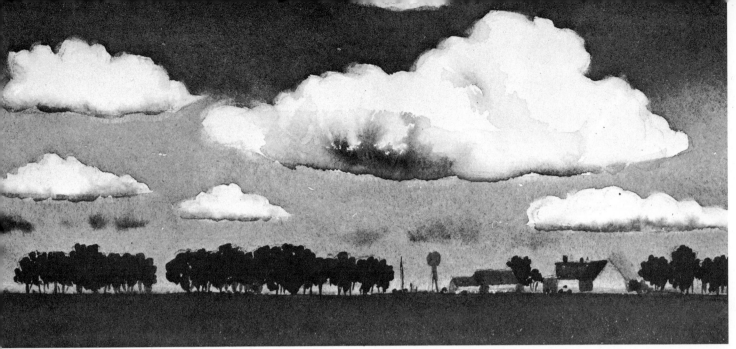

Clouds come in many shapes and patterns, too. These low-flying cumulus clouds usually mean fine weather.

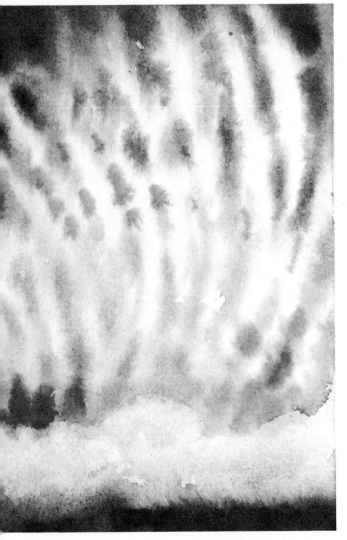

Fleecy altocumulus clouds are sometimes described as a mackerel sky.

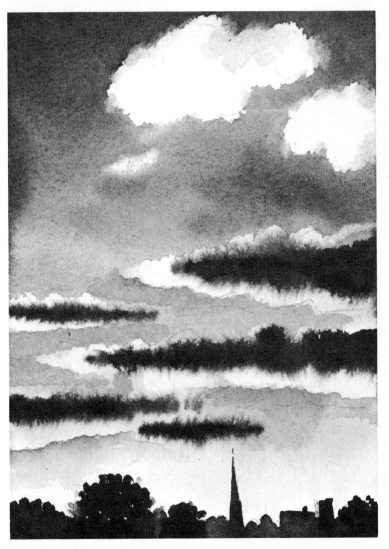

Sunset clouds.

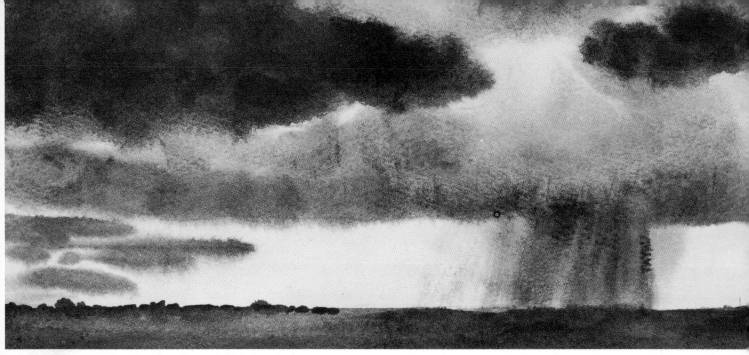

A cumulo-nimbus cloud, with rain falling from its base.

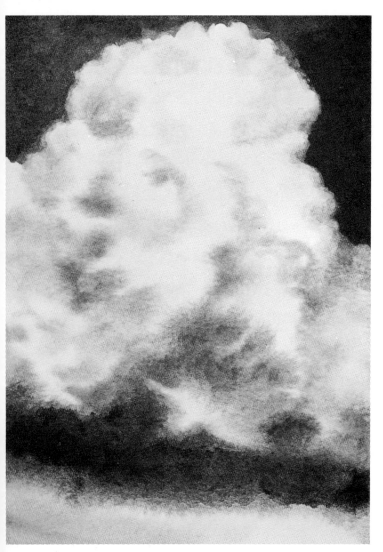

The cumulo-nimbus is commonly called a thunderhead.

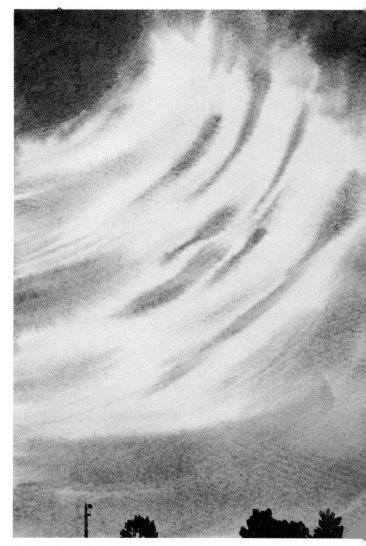

Wispy cirrus clouds, sometimes known as mare's tails.

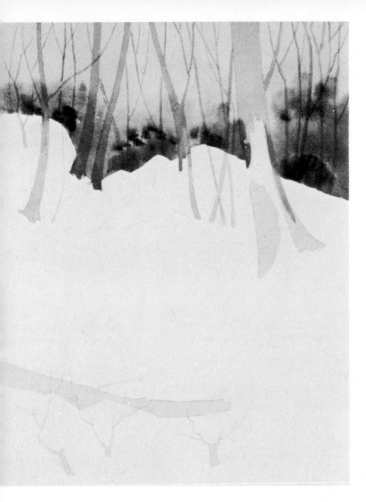

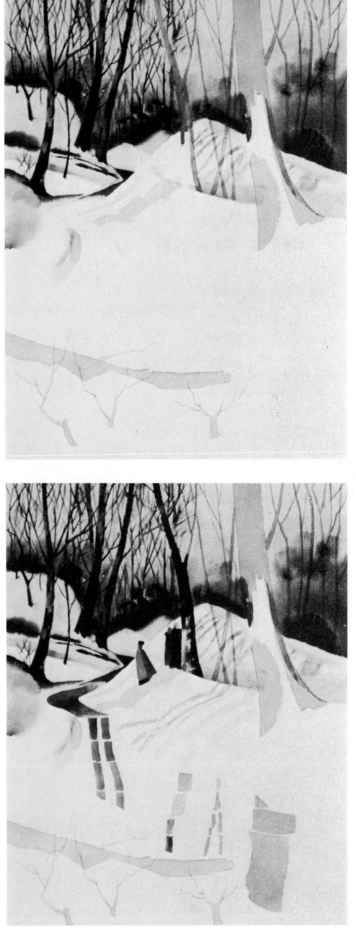

In a snow scene, try to keep as much of the unpainted white paper as possible. First, using a 1″ brush, I wet the area of the sky and the distant trees, brushing the water well into the space. One important thing while doing this is not to get puddles; you should be striving for a smooth filmlike texture. At this point, I painted the sky and distant trees and, when the paper was dry to the touch, added the darker values of the closer trees. The second picture shows the lacelike effect of the background trees after I had painted the smaller branches. The final step is very important, since this is where you have to take care that your edges don't get too straight or regular. Study the lines in the painting on page 80 and notice how they seem to have a fluid movement.

In Cuenca, Spain, I stopped to sketch the *casas colgadas* (hanging houses).

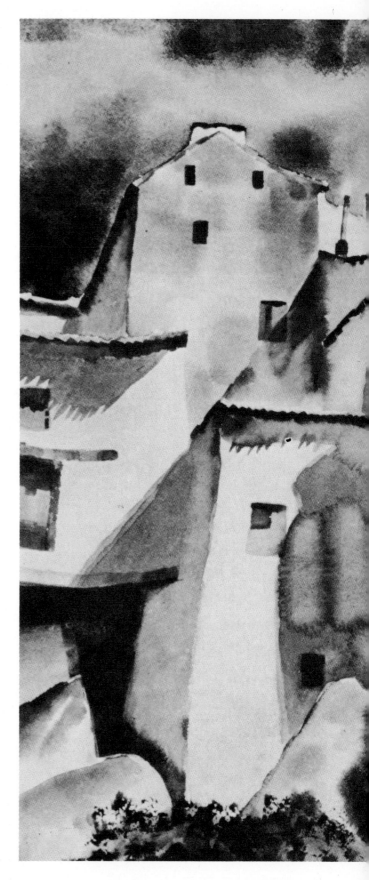

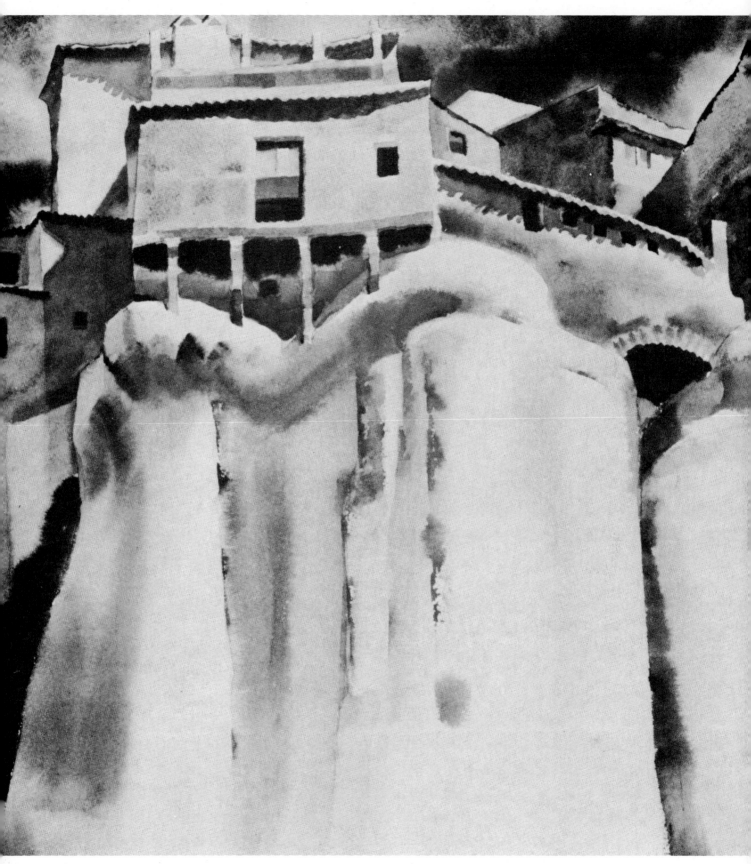

Casas Colgadas, painted on a half sheet of Imperial Arches 300-pound paper.

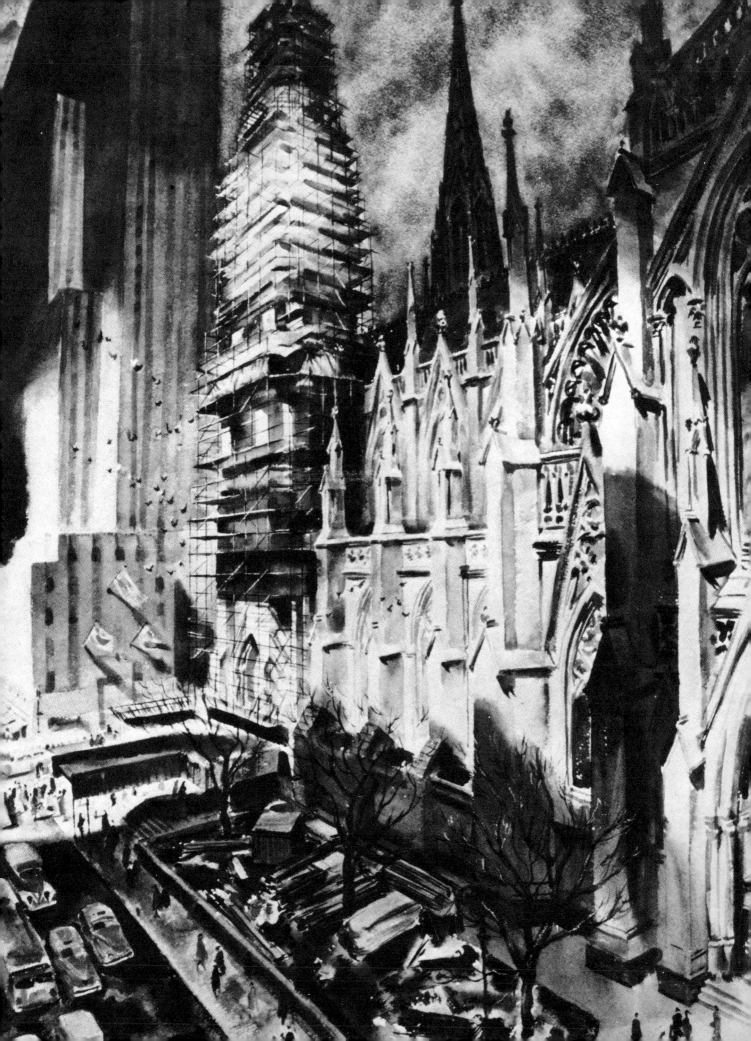

Cityscapes attract a different breed of artist, one who is quite distinct from the landscape painter. There is a wealth of material for painting in cities, such as the different landmarks which form part of their histories, diverse and interesting architecture, and street scenes.

It is usually wise to avoid getting involved with the picky details of a city scene. For example, the statue of an angel at the head of a bridge in relation to the rest of the cityscape may well become simply two rectangles of grays and whites when translated onto paper. Buildings should be patterns rather than architectural renderings. Forget the common idea of perspective. Somewhere, there is a computer that can draw better perspective than we poor mortals anyway. Think of buildings not as many different units but as one building with different rooftops.

The spirit of the city is very important. Even if you "can't draw a straight line," I am sure that if someone asked you to suggest — with just a few scribbles — the city of Paris, you would probably draw a lot of chimneys and a series of crooked little roofs and you would probably have it.

Seascapes can be divided into three types of scenes — a lagoon or bay, a seashore, and deep water. Lakes are, for painting purposes, bays.

Water is like a mirror, but when the wind comes up, the wind smashes the mirror so that you have all the minute mirrors in different positions.

Distant water gets the addition of pockets of shade within a small visual area. If you will observe the arm of a man who has dark hair, you will see that the edges of his forearm appear darker as his hairs are added together — you see many hairs instead of just the few scattered ones on the middle part of the arm. The same principle applies to water.

In seascapes, the area of the picture can be divided into three parts — forewater, middle water, and distant water. The distant water usually is much darker than the rest. The middle water usually is the actual color of the water and the forewater, near a beach or rocky shore, will appear warmer (yellower or more orange) as rocks or sand might influence the color.

In a lake or bay, the forewater will also appear to take on a warmer color near the shore and appear darker further out, where the water is deeper and more compressed.

Capturing the texture of water is important also. The forewater will appear to break up more than the middle water, which will appear flatter. The distant water tends to look like a solid mass and texture disappears. Only the mixture of the light and dark prevails as an untextured tone.

But, as is often the case, there are exceptions to these concepts. In a sunset, for example, the distant water may turn into a mirror reflecting the sun, in which case it becomes a glittering area.

In lakes or cove water, assuming the absence of wind, water will reflect virtually an identical image to the object that appears above it. It is only little deviations — a leaping fish, a water bug skimming the surface, or a stone thrown into the water — that will mark the surface and establish the reflection as that of water.

Wind serves the same purpose. It turns the still, reflected image into something like the mirrors one encounters at amusement parks, distorting the surface and turning the water into a series of concave and convex mirrors.

Remember that what you leave out of a picture is just as important as what you put into it. The painter has a great freedom in his ability to alter or restructure that which he uses as a model.

The best advice of all is simply: Look.

Repairs at St. Patrick. This award-wining picture was painted in 1950.

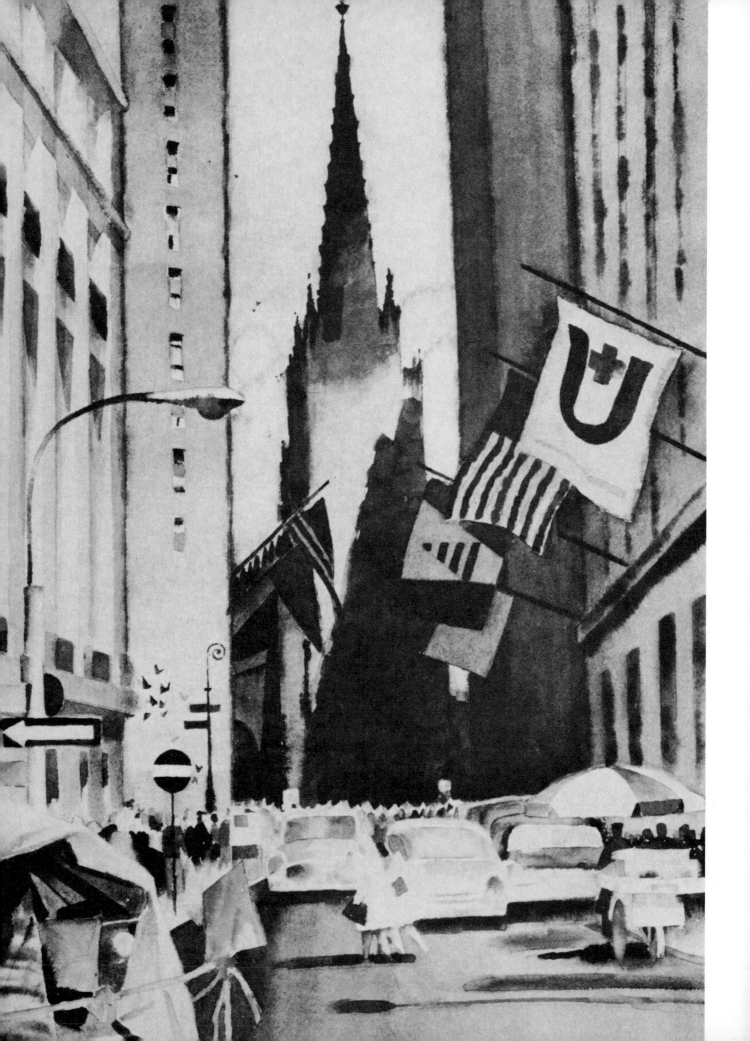

Facing page, *Wall Street*. Painted especially for this book, the picture shows greater simplicity than *Repairs at St. Patrick* on page 100.

East River. The painting, done in 1952, won an award from Allied Artists. My later paintings get much simpler.

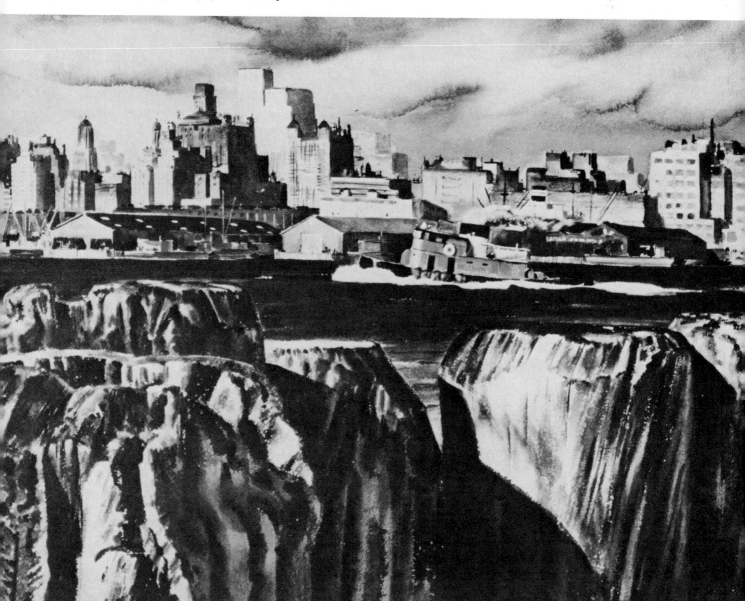

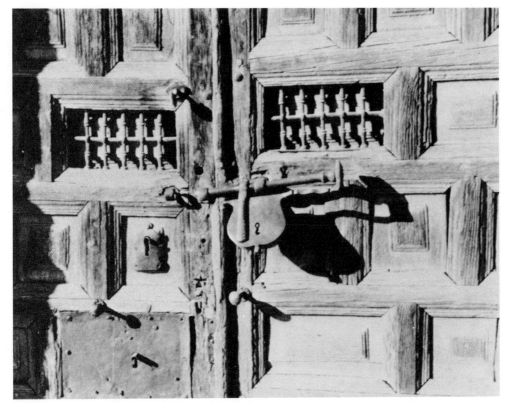

I took this 35mm. slide of a door and lock in Segovia, Spain. Below is one of the many studies that preceded the painting at the right.

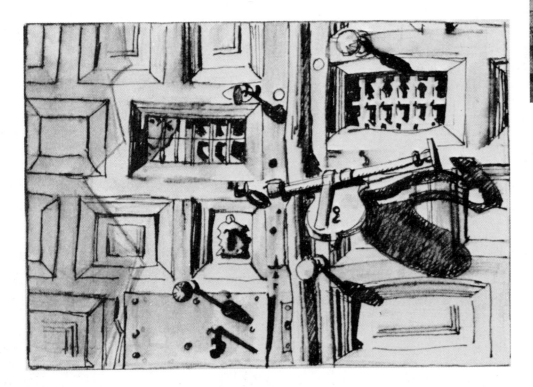

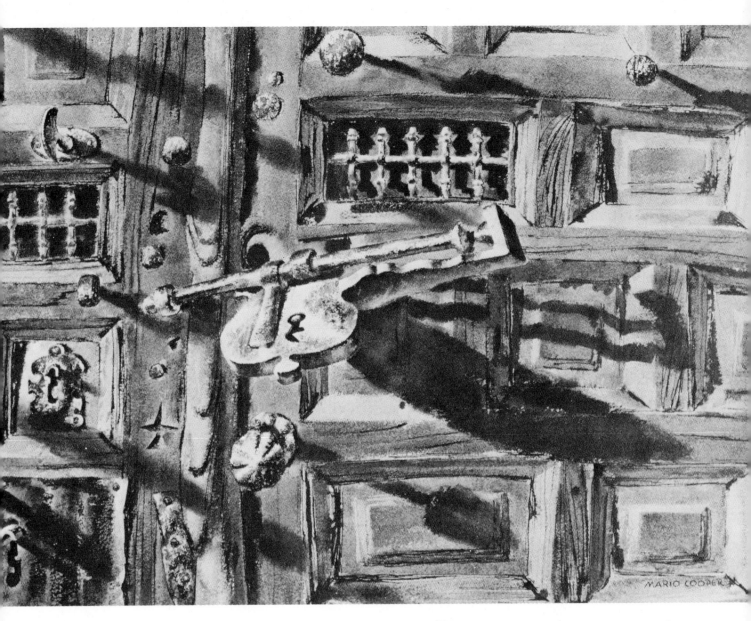

Segovian Door. The final painting, which won an award in the 96th American Watercolor Society's Annual, was done on Double Elephant 200-pound Fabriano. I used pen and ink for the under-drawing and then watercolor over the ink lines. The drawing on the right is one of the many I did as I viewed the 35mm. slide.

Martha's Vineyard. I was struck by the marlin tails nailed as trophies around the house and dock, and so I decided to paint a "Marlin Tail Symphony."

Overleaf, *Squatter's Cove.* This painting was done in Port Washington, circa 1950.

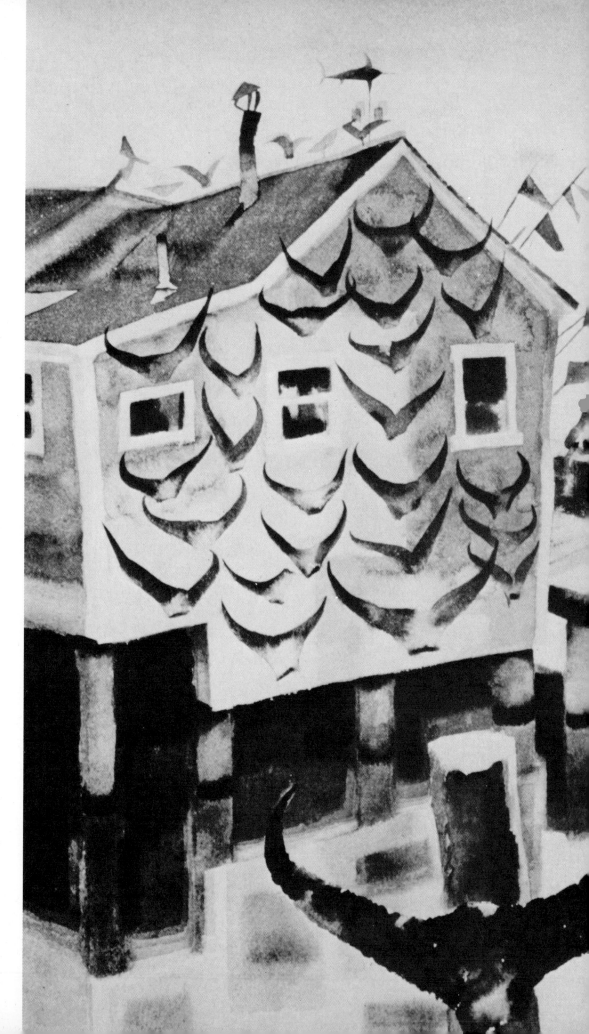

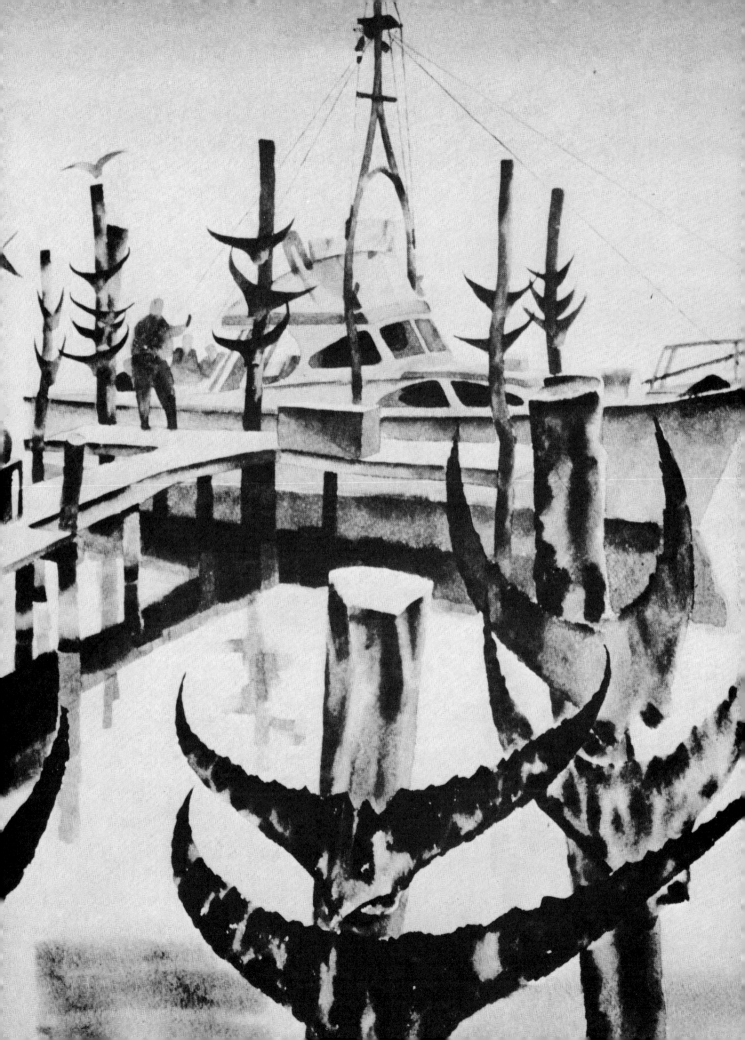

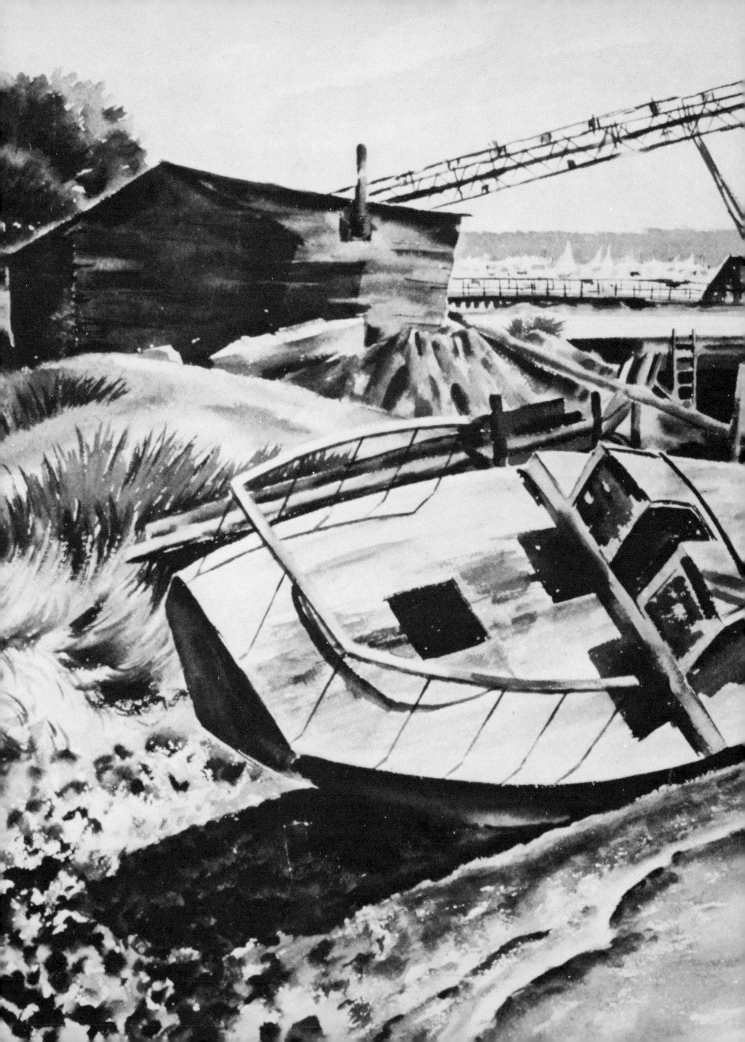

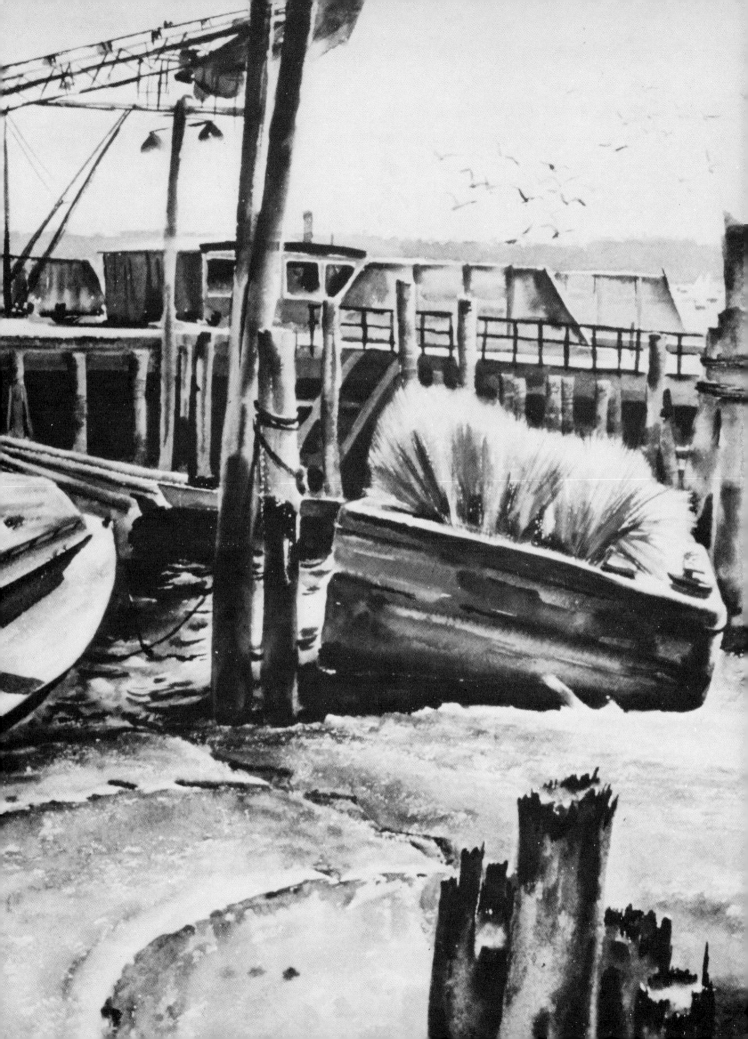

These diagrams illustrate the difference in appearance of the three different elements in a seascape — distant water, middle water, and forewater. The No. 1 arrow points to the distant water, which is usually a simple color plane without texture that is usually darker than the rest; the No. 2 arrow points at the middle water, whose texture may be marked as here, by small strokes in the distance that get bigger as they approach the forewater; the "A" arrow indicates an "interfering" plane that acts as a wall; and the No. 3 arrow points to forewater, whose texture, in this case, can be described as open, and punctuated by a series of ovals and serpentine shapes.

The distant water of the ocean fuses into a dark area, as shown by No. 1, and, again, the middle water (No. 2) begins to show signs of texture. In the forewater (No. 3), there are large separate peaks — minute mountains, almost.

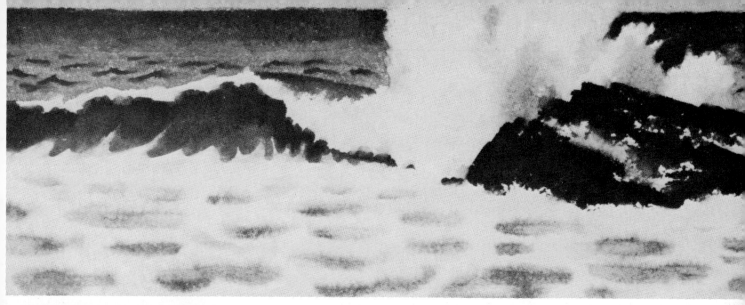

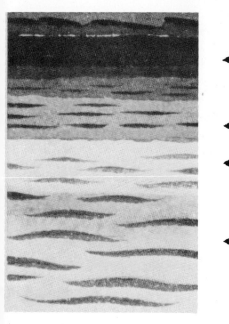

1 ←

2 ←

A ←

3 ←

In lake water, the distant water runs together, as shown in No. 1, and has no discernible texture whereas in No. 2, the water seems to pick up texture and the brush strokes on the water are more lyrical. The "A" section indicates an interfering plane caused by the wind or some other disturbing agent, which usually turns the surface into a series of mirrors that give off extreme highlights. This is best denoted by keeping the white of the paper. In the forewater (No. 3), the brush strokes should be bigger and further apart.

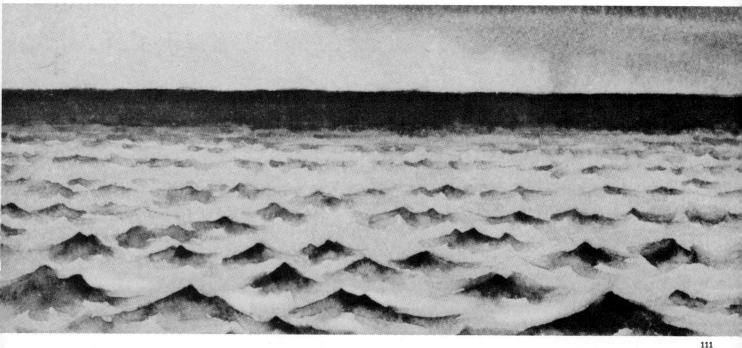

Moss Cove. It was on Laguna Beach, California, that I did this thirty-five minute sketch on the spot "in wet." (See page 127 for the explanation of this technique.)

It is very important to keep in mind that our art has three different pictures — "the sketch," "the study," and "the finish." The sketch should be kept a sketch, and under no circumstances should you try to make a finish out of it — because if you do, you *will* finish it. It is far better to keep it promising and a masterpiece of a sketch. Now the study is intended to be what the word implies; you have seen many studies that are masterpieces of their type, and again, you should keep them that way. Finally there's the finished picture, which is done with

Pounding Surf. I did this thirty-minute sketch on the spot
on dry paper at Peak's Island, Maine.

all the aids at your command: sketches, studies, slides —
you name it — you use it. Often a sketch will have more
art, spirit, and life than a finished painting, while the
finished painting will be heavy with craftsmanship and
thought.

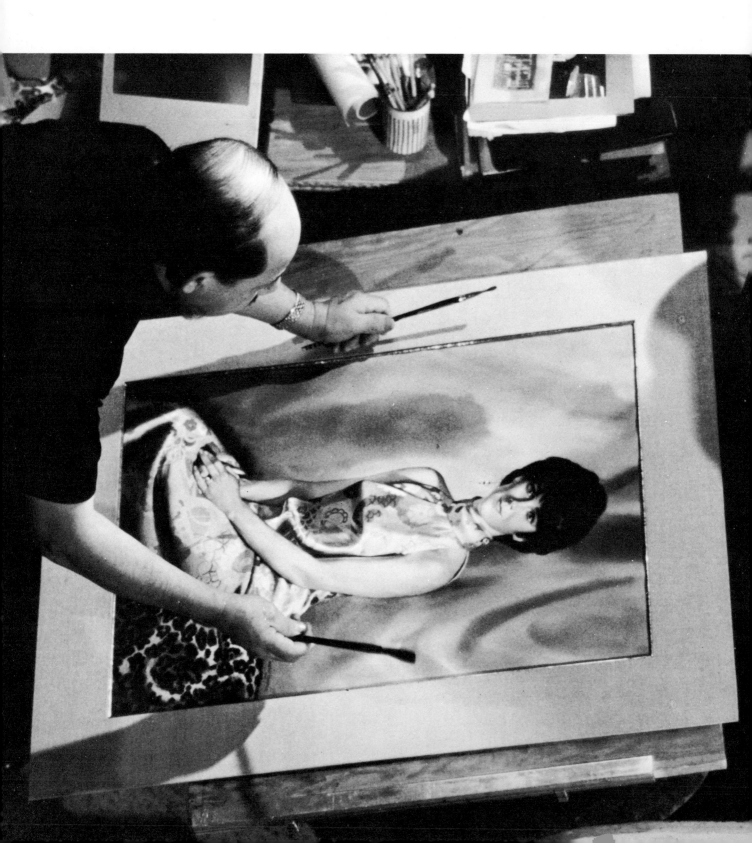

People's faces come in a variety of types and shapes. There is the heart-shaped face, the triangular face, the round face, and the proverbial hatchet face.

The first order of business in painting a portrait is to determine just what kind of a face you're dealing with. From that, you can put down on paper your basic shape.

There are some important differences between the shape of a man's face and that of a woman. A man's head, generally speaking, has lines that are straighter, more staccato, than a woman's. His neck is thicker, his eyes are closer to the eyebrow and generally squintier. His silhouette is usually made up of straighter lines. The nose is longer in a man and meets the forehead sharply whereas a woman's nose begins to anticipate the forehead and begins to curve to meet it.

The neck of a woman is narrower and usually longer; a man's is sometimes so wide that it appears to join the head with no space between. The female silhouette has more concave curves, her eye sockets are usually wider, especially at the corner of the eyes, and her eyebrow seems to trace more of a winglike arc. Lips are wider in a woman than in a man and her eyes are usually bigger.

There are two important things to remember when drawing or painting an eye. The first is to have a shadow on the eyeball from the upper lid. The other is the highlight on the eye which should occur over the pupil.

It may be helpful to think of the lips as a cone sliced in half for the two sides of the upper lip, a prism for the center, and an ovaloid cut in half for the lower lip. Put these elements together and they form the lips.

In a profile, beginners often don't allow enough room for the eyelid over the eyeball and the result is something peculiar.

Think of the nose as a geometric form. The lower part forms a prism, and the most important part is suggested with this prismlike portion of the nose as it turns to meet the canal of the upper lip.

Now, something really tough: the hands. Many people who paint a portrait hide the hands because they are afraid to try to do them.

I have found that a great help in drawing hands is to conceive of a hand without the thumb and fingers. The thumb, while extremely important, can quite often interfere with the flow of line so that it is better to do the initial drawing without the thumb and simply add it later in whatever position it fits most logically.

Also, if you conceive of the body of the hand first — with the fingers left out — you can indicate the circular sockets where the fingers join the hand. This will keep you from making fingers that are too wide for the width of the hand.

Position of the fingers is important and you should take care that it does not become monotonous. Clasp your own hands and look at them. You'll see that there is a great deal of sameness about them. Experiment with phrasing them in different ways. Your subject, without any loss of character, can phrase his fingers to the best artistic advantage.

In painting, ears are usually the most neglected area of the head. Again, a rule-of-thumb formula based on three circles can keep the ear from looking like a bent hairpin. (See page 120.) Most dictionaries carry a good diagram of an ear with the names of all of its parts. However, you should be concerned not about the technical aspects of the ear, but rather its basic shape.

Highlights in hair are just as important as highlights in fabric — as in silk, for example. Remember also that the rhythm of hair is important. No matter how straight hair appears, it still has a rhythm and it is the artist's job to capture it on paper.

As I study a portrait of Dale, Jr., I am wondering whether it could possibly use some additional touches.

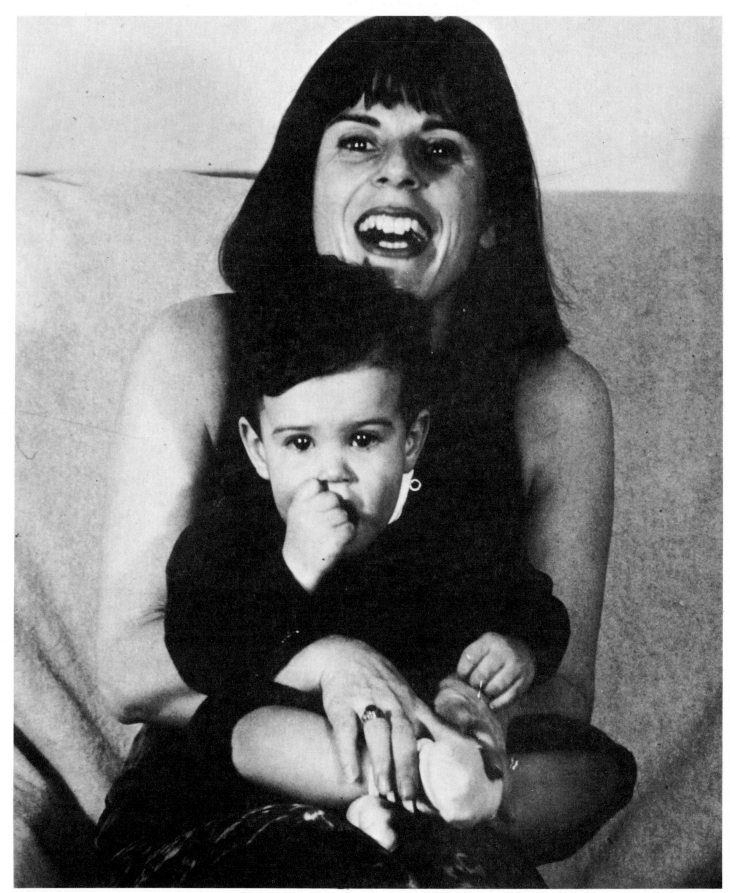

I took a 35mm. slide of Patricia and Scott.

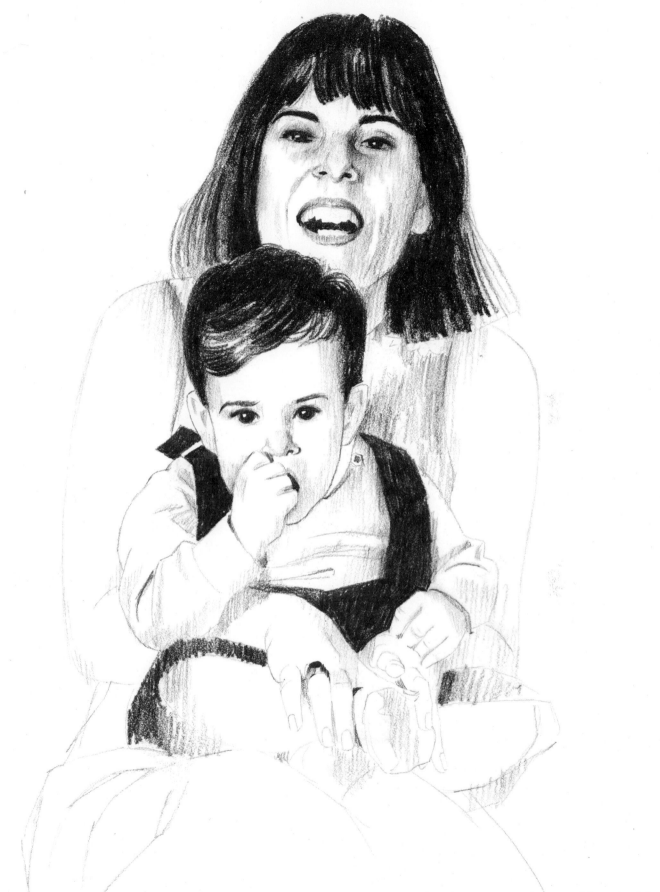

Then I made a sketch with a carbon pencil from the slide.

It is important to remember that the eyes in an adult are midway between the top of the head and the chin. However, in the child the eyes are two-thirds of the way down from the top of the head, and so a child has a small face and a big head.

Compare the profiles of the man and the woman. The woman's lines are more lyrical — more convex and concave — whereas the man's lines are straighter and more angular. Compare nose, chin, mouth, neck, and eyes.

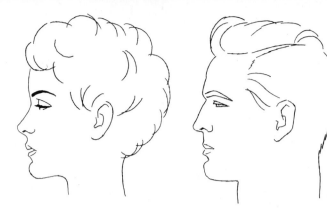

The diagrams below should help you in drawing the nose. Under A, B, and C, you have the nose divided into geometric elements, whereas D and E indicate how to keep the shadow of the nose on the face to a minimum. The reflected light on the nostril prevents the area from becoming too dark. F represents a woman's nose in profile; note how the nose is turned-up. Sometimes noses have a cleft (G) where the two segments of cartilage meet. H to O depict more types of noses and the ways you can draw them.

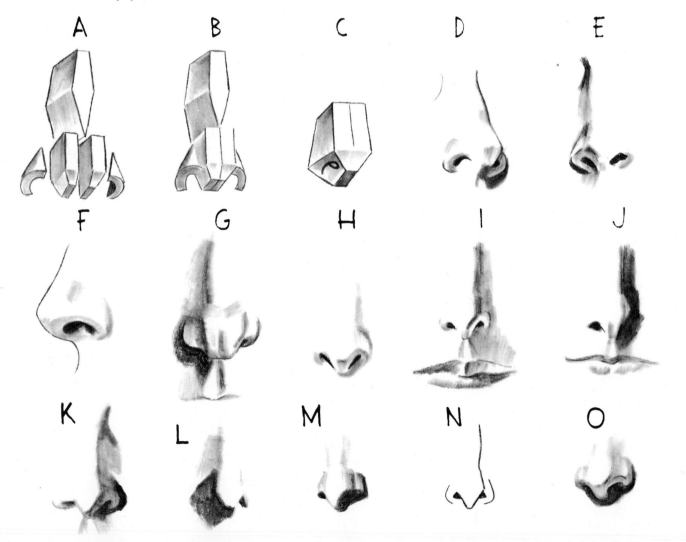

The eyebrows of the female seem to rise upward like a pair of wings (see A) and they are generally set wider apart than the male's (B). In addition, the female eye socket is usually wider from the eyebrow to the upper lid. C, D, and E are eyes from movie stars. (Can you recognize them?) F and G depict older eyes. Remember that the upper lid casts a shadow over the upper eyeball as a result of the heavy eyelashes of the upper lid, and this shadow will keep the eyes from "popping out." The highlight on the eye, which is right over the black pupil, should be paper white, and the pupil as black as you can make it.

In A, the geometric elements of the lips are shown; see whether you can find these elements in a realistic sketch (B). C shows the lips in profile; make sure that the teeth stay inside the lips. In D, you can see that the silhouette and curve of the lips are important since they help to denote the position of the face. When you want to show teeth, you should do so only by outlining, as shown in E.

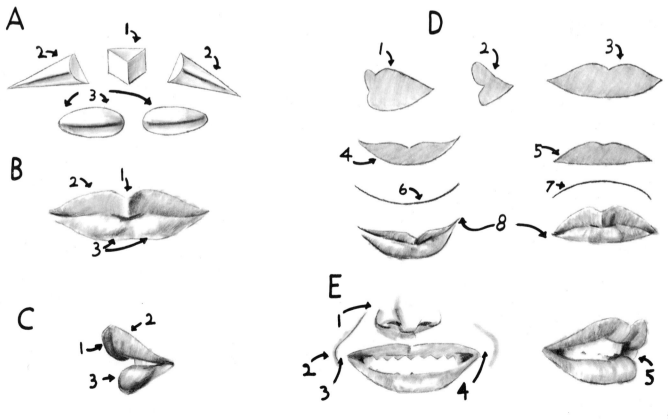

Opposite page. How you group the fingers is very important in drawing hands; A, B, C, D, and E show variations. Note that fingers should taper and slightly turn up at the end, which should keep them from looking like claws or a bunch of bananas. In F and G, you see the little "V"-like shape between the two tendons of the thumb, which, in the female should be kept subtle.

Below, the basic shape of the body of the hand is simplified in A, B, C, and H. See how the fingers fit into this shape (E), and try to pick out the geometric forms in F, G, and H. The arrows point to a little neck in the thumb in D.

A and B indicate just how the curves of three circles go to make an ear. In C, the numbered parts of the ear are: 1. helix; 2. antihelix; 3. fossa; 4. concha; 5. antitragus; 6. tragus; and 7. lobe. Somehow the ears are features we notice least; however, see whether you can recognize the ears of famous men in D, E, F, and G. H shows the ear of a woman, I that of an old man.

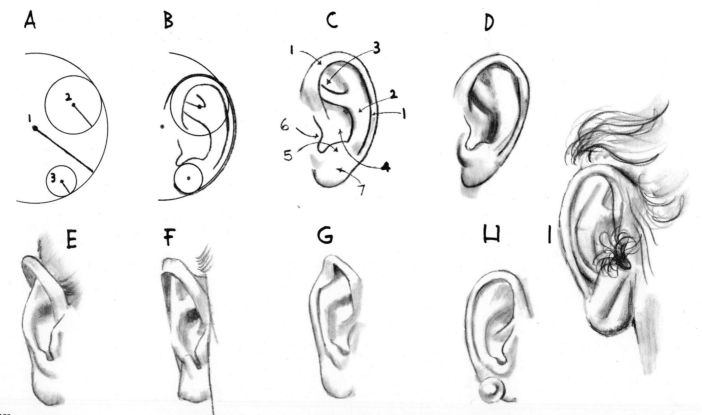

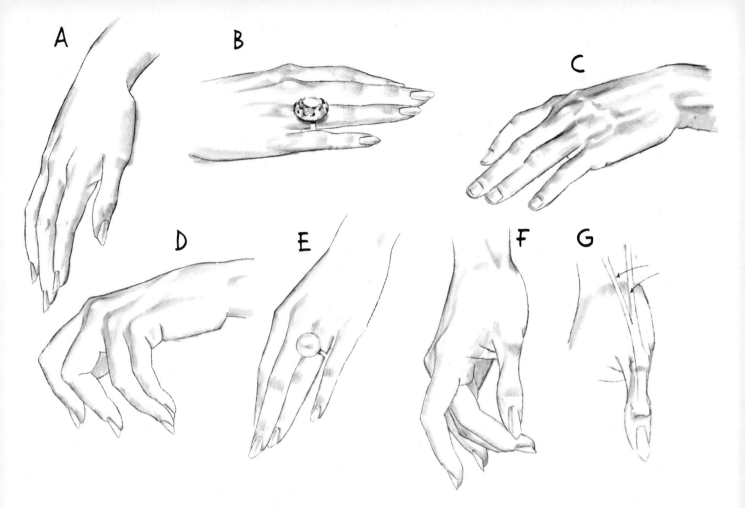

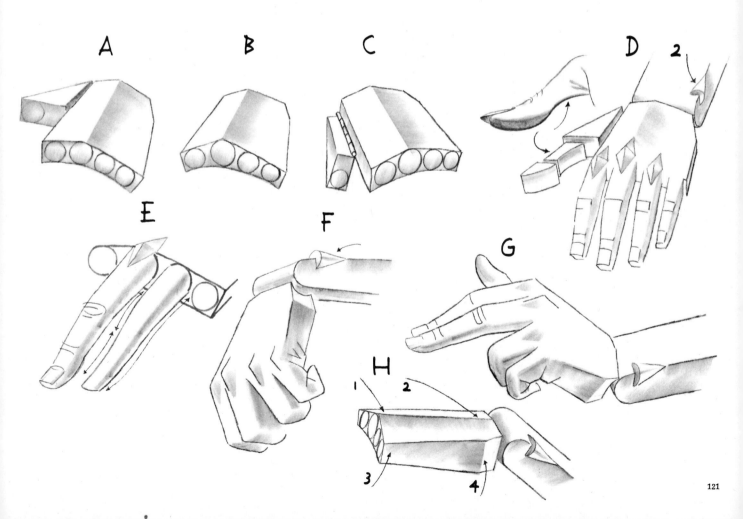

121

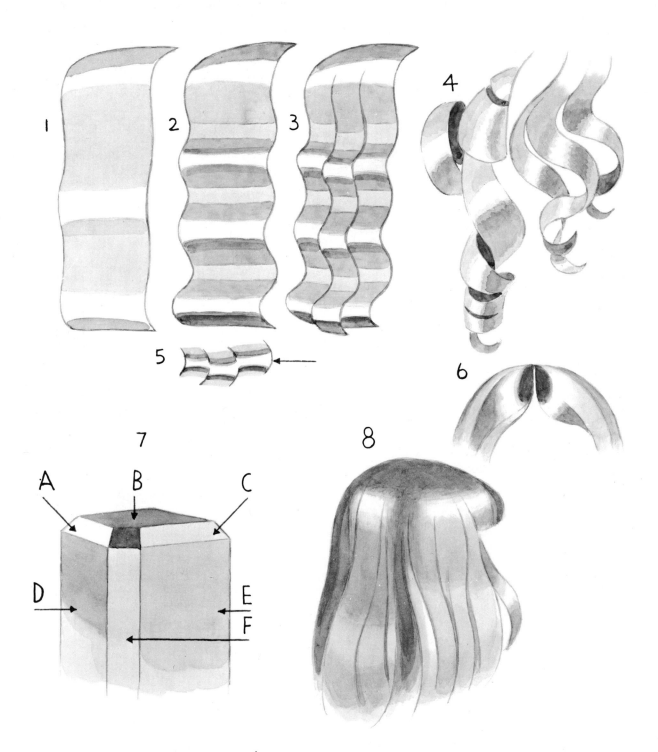

No. 1 shows how straight hair looks as a simplified form. When the hair becomes more wavy, the effect is that shown in Nos. 2, 3, and 5. The blond curls in No. 5 may look metallic, but that is a characteristic of blond hair. The most important highlights occur in the convex areas of the hair, and it is best to portray them as in No. 5, in order that they contribute to the design. Highlights emerge when one form turns into another, as shown in No. 7: the forms are B, D, and E; the highlights are A, C, and F. Try to detect the way this principle applies to the hair in Nos. 6 and 8.

Black or dark chestnut hair will have fewer
highlights — usually only one main bright one and
two lesser ones. After establishing the highlights,
the area can be tinted with blues or violets; then
the rest of the hair can be painted with a mixture of
Payne's gray and burnt umber, with additions of
alizarin crimson and Winsor blue.

Blond hair naturally holds more highlights and
therefore requires a more controlled, detailed
design. Use raw sienna and raw umber to paint
blond hair, not yellow and orange.

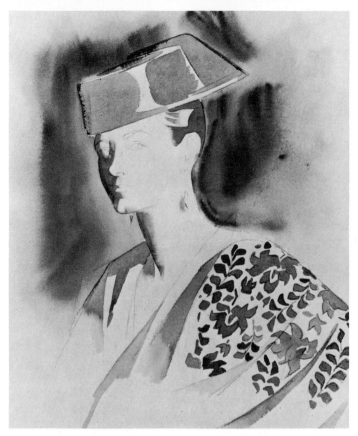

The preliminary lay-in for a portrait of my wife, Dale.

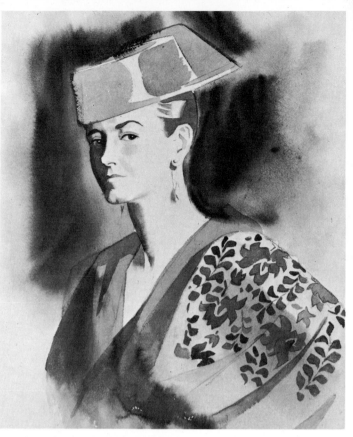

Details such as eyes, eyebrows, and ear are indicated rather than painted in at this stage.

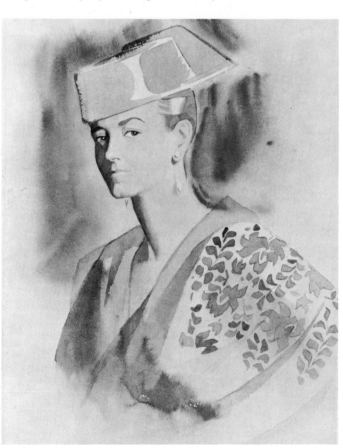

The third step shows the face developed through a series of washes. Note that the hat, even at this point, still retains its initial "lay-in." Later the whole area of the hat was wet again and, with very thick pigment, was carefully painted, avoiding the highlight. The background too was painted "in wet." (See page 127 for the fuller definition of this term.)

Facing page, *Dale in a Spanish Hat*. The whole area of the mantilla was wet again and the darks painted in wet.

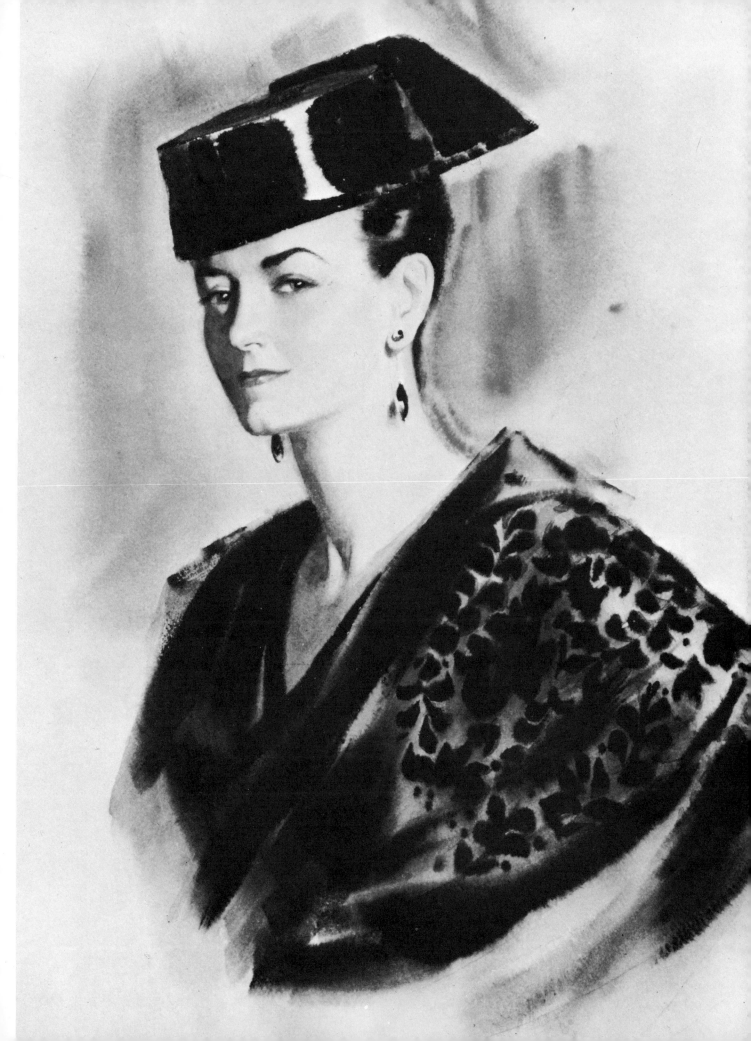

The initial design was painted in with a round No. 5 brush.

An all-over wash of silver gray is added to the gown.

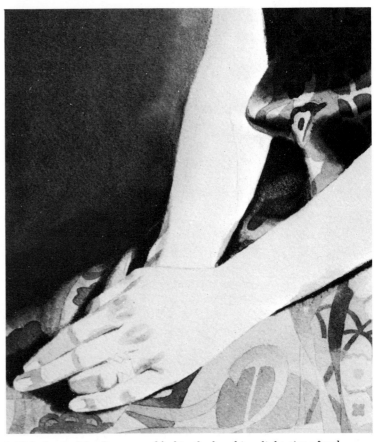

The background is added in wet.

Initial structural values are added to the hand in a light tint of red.

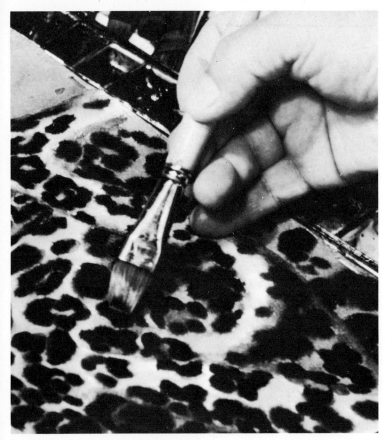

Darks are added full-strength in wet.

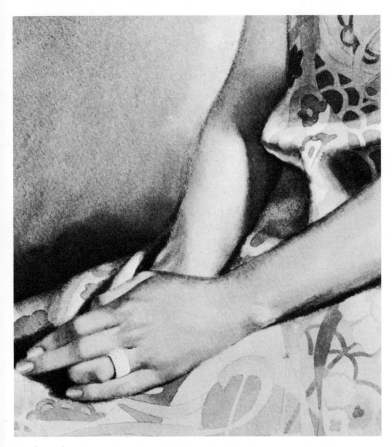

Hands and arms are developed. Notice the blank area for the ring.

The "in wet" technique refers to the paper being wet when the paint is applied. Sometimes the paper is wetted on both sides—saturated in some cases—and other times you only want one side wet. I usually paint a face in many washes and the hair in about two. First, the face area is wetted and I paint in only the color of the cheeks (pink), temple (pale blue or pale green), and neck (pale violet or yellow green), allowing the color to flow. Next, I let the area of the face dry, rewet it again very lightly, and immediately I apply an all-over mixture of flesh color. This must be done quickly because if the paper dries, you will be in trouble. Repeat this procedure until the effect you want is achieved. Only practice can teach you how you can best work with this technique. My own preference is for maintaining a simultaneous combination of dry and wet parts of paper.

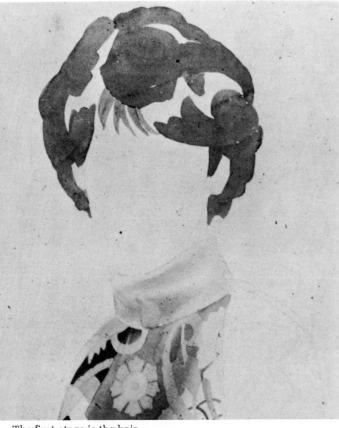

The first stage is the hair.

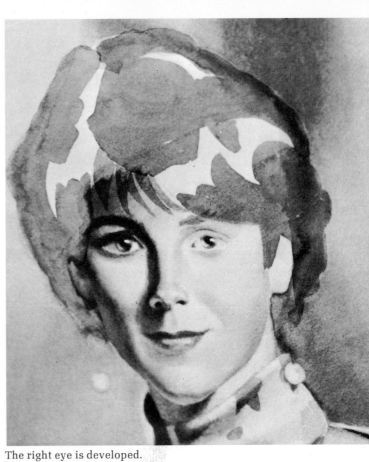

The right eye is developed.

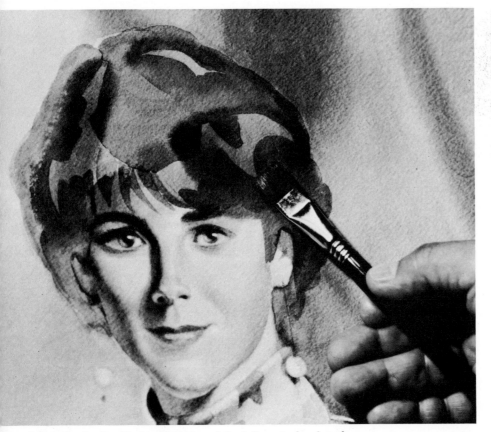

A tint of color is added to the hair and the left eye is developed.

Facing page, *Dale Jr.* The hair was painted in one operation in wet. Notice the intense dark on the ring and the white of the paper.

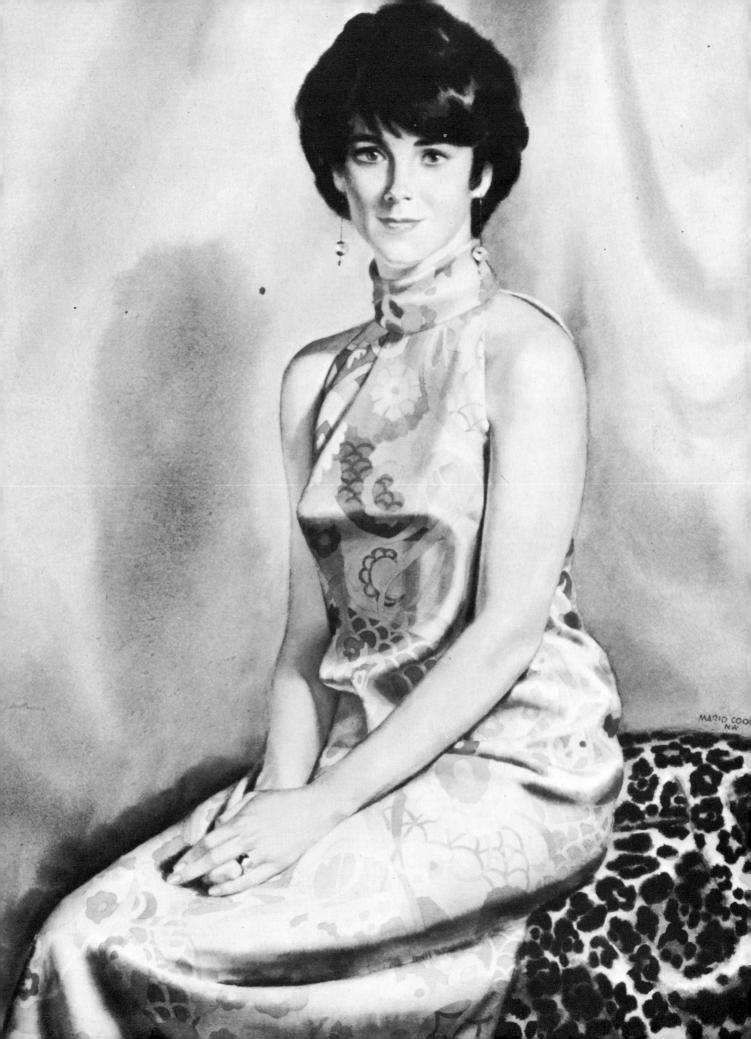

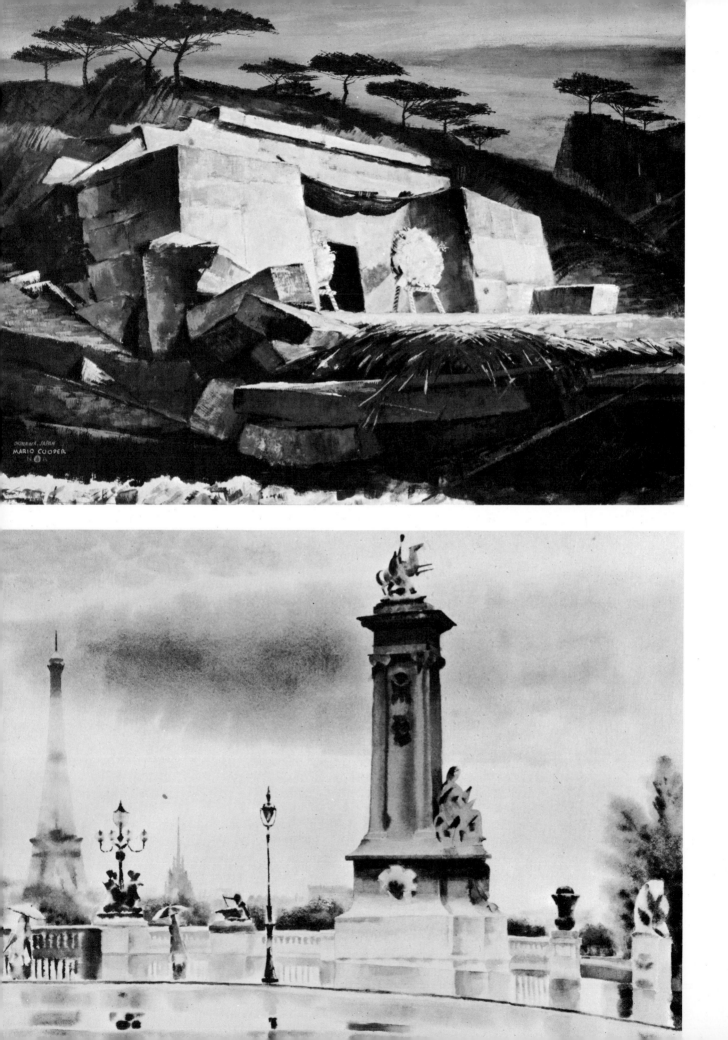

And what exactly is style? Style in art refers to those qualities of an artist's work that mark it as unmistakably his. How does one get a style? That's a little tougher to explain.

Too many of us overemphasize style and technique. What we don't realize is that style is an intuitive thing. It is something that most of us are born with. It shows in almost everything we do that is natural.

One of the most rewarding aspects of teaching is being able to spot the beginnings of a distinct, personal style in a student and bring it out of him, help him develop it into something unique.

Sometimes, style is a matter of solving your own technical problems. Some psychologists claim, for example, that El Greco's style — that of eerie, elongated figures — was the result of an astigmatism. This may or may not be so. However, things of this sort are sometimes the case.

The best way to develop style is to learn all the basic concepts of technique to the point where you simply forget about them and paint. It's like carrying a cup of hot coffee which is filled to the brim. As long as you're unconscious of the cup, chances are nothing will spill. The minute you start to worry about it, you'll invariably lose some.

So it goes with painting. The person who is simply caught up in technique will never develop something personal to say. It's like knowing every word in the English language and not having anything to say.

Style is also a product of your life. To be a painter, you have to think like a painter. This doesn't mean that you have to move into an unheated garret and eat one meal a day. What it does mean is that you must be receptive to the world around you, develop better ways of seeing, and explore the possibilities of presenting your ideas to the world in a fresh light.

If you have something to say in painting, people will listen. If you don't; well, they won't.

There is a story about a fellow carrying a violin who asked an old man at the corner of Fifty-seventh Street and Seventh Avenue in New York how he could get to Carnegie Hall. The old man looked at his questioner wryly and answered: "Practice, man. Practice." The same is true of style in painting. Practice will develop it, strengthen it, and — when you've really achieved your goal — put its importance in proper perspective.

What it boils down to is this: the only way to have a style of your own is to have a point of view of your own. This means that your thinking has to be your own, also. The only way I know that you can develop this type of thinking is by trying to attain simplicity of thought and a visual simplicity in your work.

Pindar, one of the greatest lyric poets of ancient Greece, told the story of a criticism from a fellow student — a young girl by the name of Corinna — who must have been a pretty good poet herself since she topped him in his school competition. After reading one of his poems, Corinna said to him: "When you sow, sow with the hand, not the sack." In short, say more with less.

Another story that demonstrates the same point is the one about a Japanese gardener who was expecting a visit from the Emperor. The gardener surveyed his roses, reflected for a moment, and then cut them all except for one.

To me, these stories demonstrate the great power of simplicity.

There isn't a book you can study or a school you can finish that can certify you as an artist. Everything you see, everything you read, your relationship to all the other arts — these will help you find yourself.

Top: *Tomb in Okinawa.* Casein tempera painting, circa 1955.
Bottom: *Pont Alexandre III.* A recent painting done in Paris.

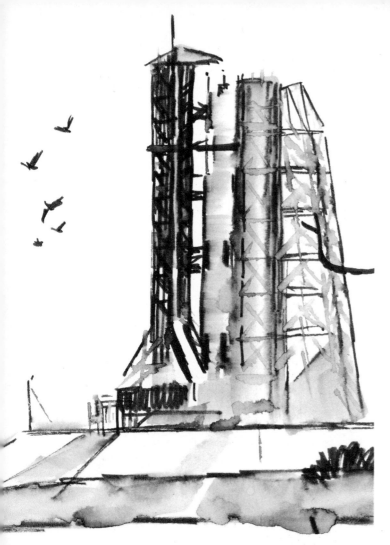

Sketch of Apollo 11 on the pad at Cape Kennedy, 1969.

The Glittering Hours. The first version of Apollo 11 on the eve of its historical ascent to the moon is in the collection of NASA and was shown in the National Gallery in Washington, D.C. I reduced all natural phenomena to design elements which ended up being very satisfying.

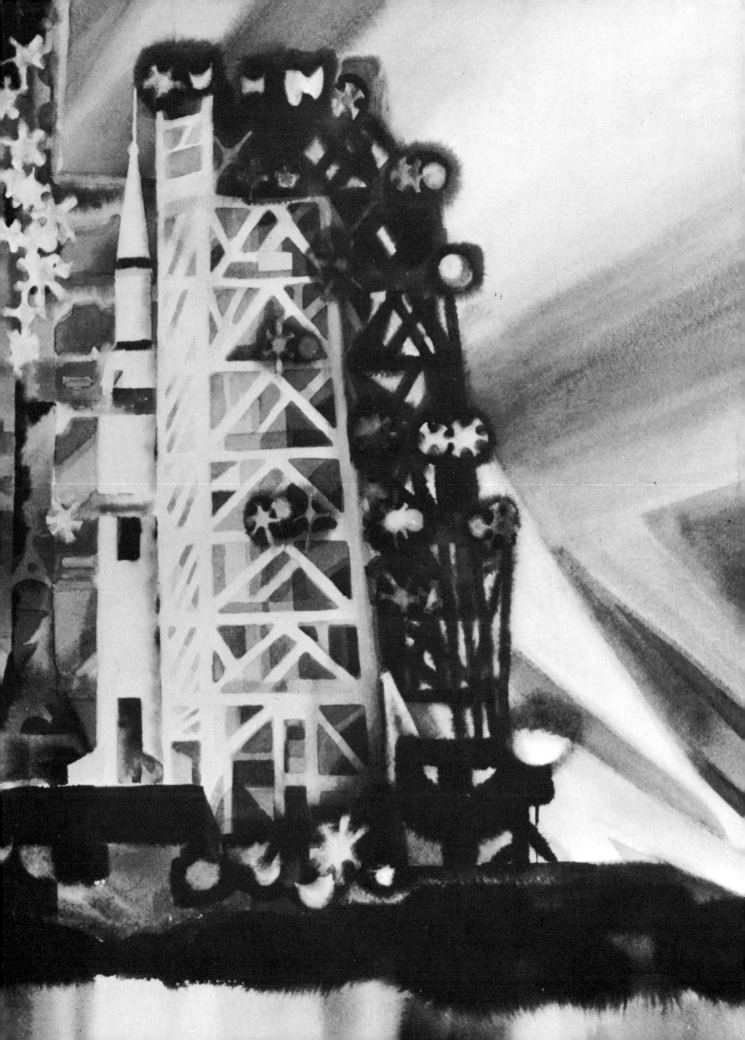

As stated before, a painting should have as its foundation an abstract design, which is sometimes hidden in the well-developed painting. Although the casual painter may handle his areas freely, his composition can be well-thought-out. On the other hand, some artists insist on absolute control. Whichever style you prefer is a matter of personal taste; just be sure you have a good composition.

Casual rendering.

More control, more decorative.

Complete control.

Casual rendering.

"In wet" rendering.

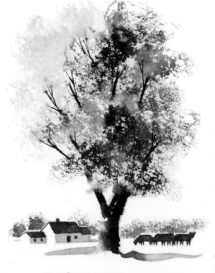

Rendering with a sponge.

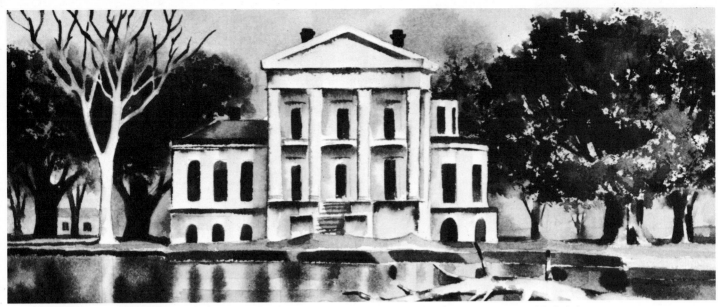

In this more-or-less casual rendering, the tree at the left was done with the flat side of a No. 20 sable brush.

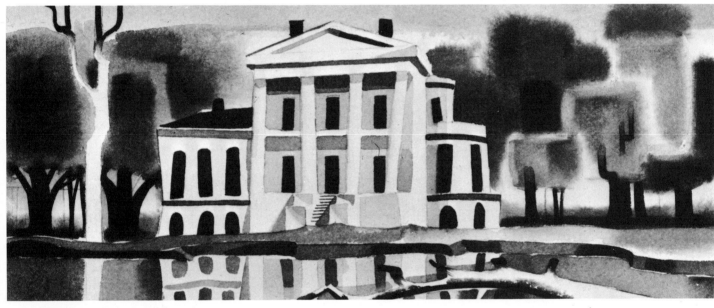

Semi-controlled area of the same scene.

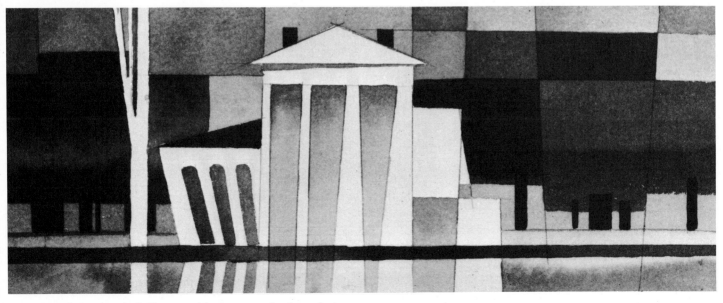

Complete control of all areas with strong emphasis on design.

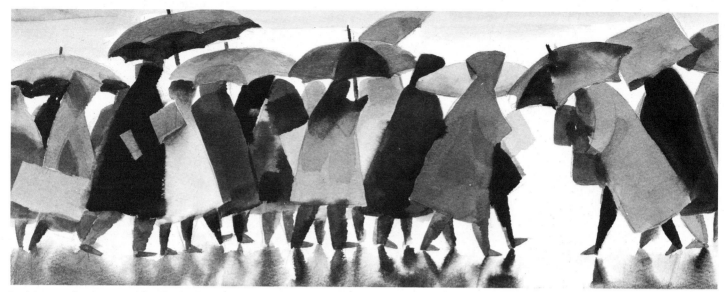

In this casual painting, umbrellas look like umbrellas and feet like feet.

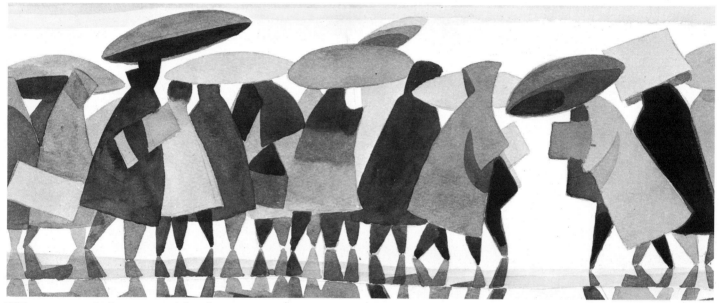

With more control, elements are reduced to geometric shapes.

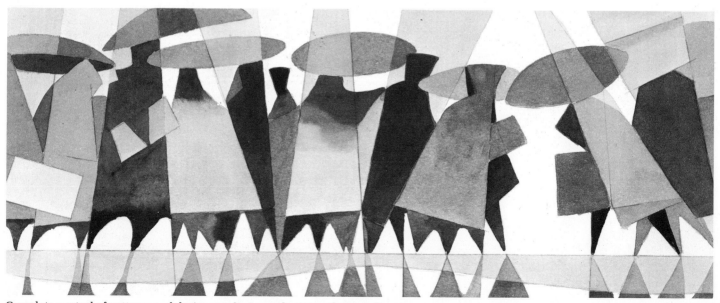

Complete control of patterns and design results in emphasis on abstract shapes.

Note the casual rendering of the King's Palace in Brussels.

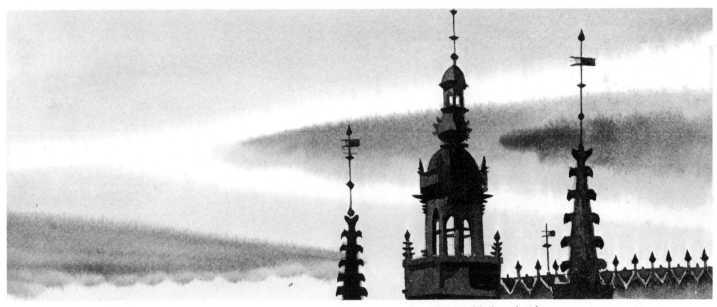

In this version, there are some controlled areas, and geometric patterns have been added to the sky.

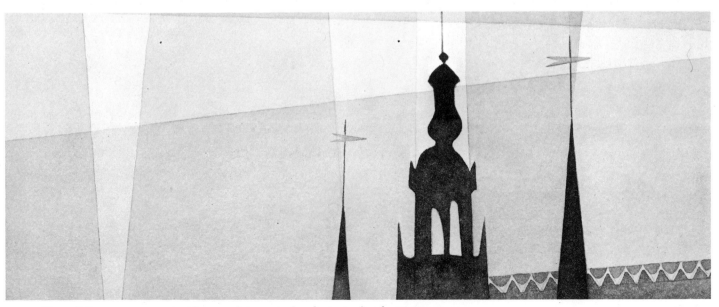

Now all the areas are marked by complete control and personalized patterns.

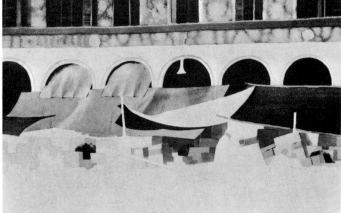
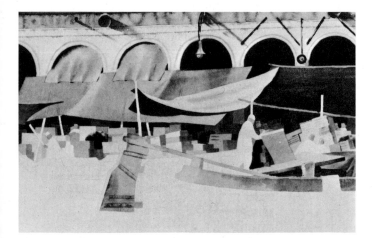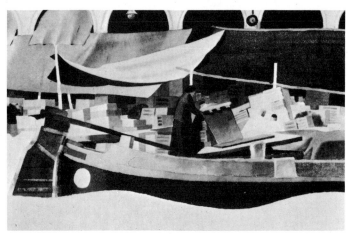
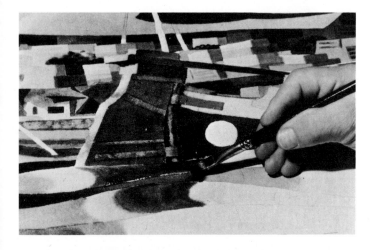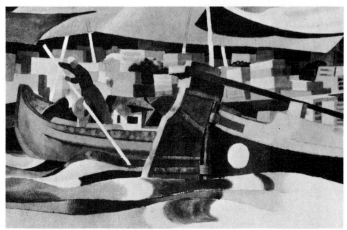

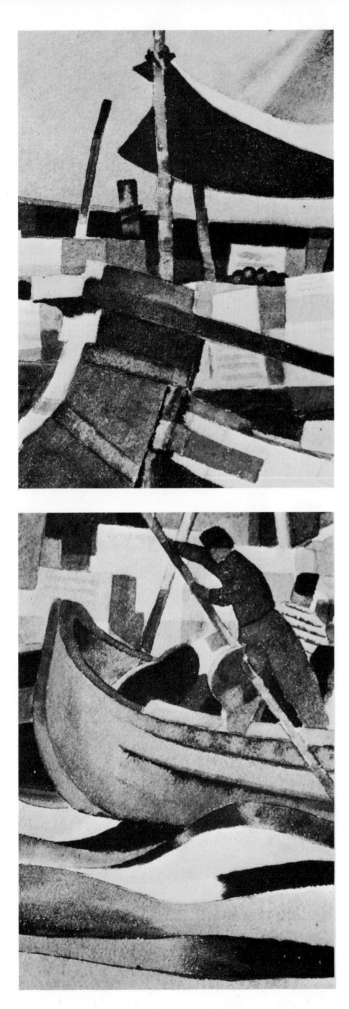

Study these step-by-step pictures of *Venetian Market* to follow the development of an exhibition picture. This kind of work is not done in one day — it is the result of countless sketches. Once you've decided on the final sketch, you do the painting in sections, pretty much like a fresco. Examine the close-ups of the details in order to pick out the strong patterns and abstract quality.

See the next page for the finished painting of *Venetian Market,* which was done on 300-pound Imperial Whatman.

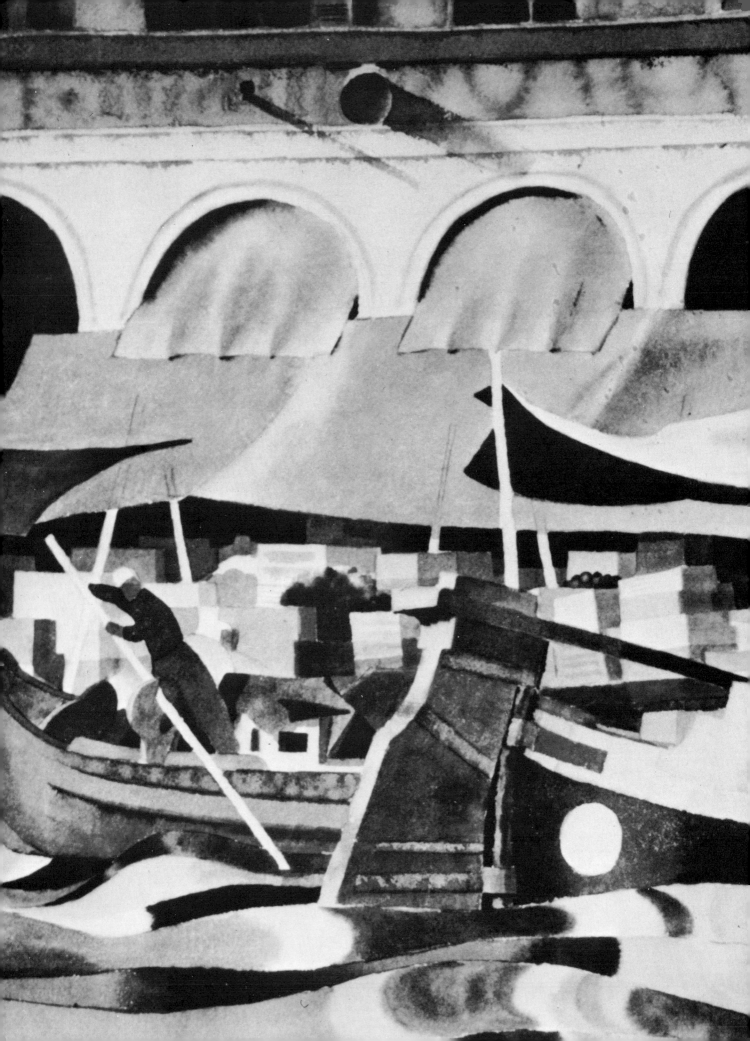

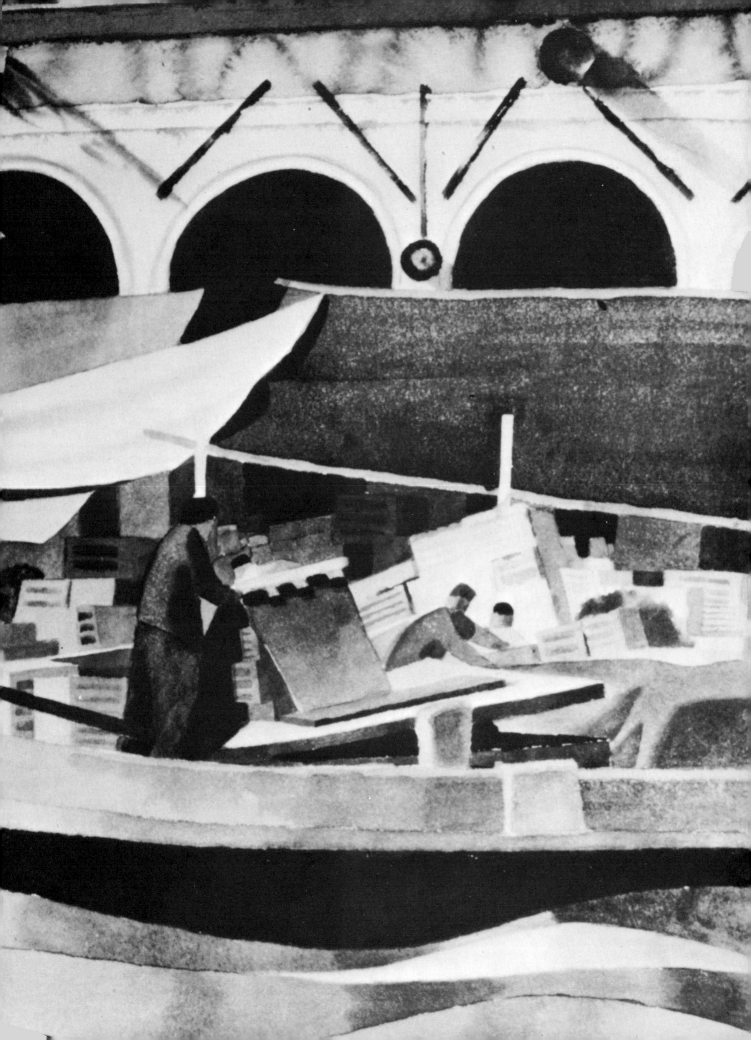

PICTURE CREDITS

Permission was granted to reprint: *Lady in Grey* by Whistler, courtesy of The Metropolitan Museum of Art, Rogers Fund, 1906; *Bird of the Spirit* by Morris Graves, courtesy of The Metropolitan Museum of Art, Arthur H. Hearn Fund, 1950; *John Biglen in a Single Scull* by Thomas Eakins, courtesy of The Metropolitan Museum of Art, Fletcher Fund, 1924; *Piazza di San Marco* by Maurice Prendergast, courtesy of The Metropolitan Museum of Art, Gift of the Estate of Mrs. Edward Robinson, 1952; *Clover Field in June* by Charles Burchfield, courtesy of the Metropolitan Museum of Art, George A. Hearn Fund; and *Along the Seine* by John Marin, courtesy of the Metropolitan Museum of Art, the Alfred Stieglitz Collection, 1949.

In addition:
The photographs on pp. 6, 16, 25, 46, 62, 63, 64, and 114 are by Burk Uzzle.
The photograph of the painting on p. 8 is by Ralph Morse. The photographs on pp. 18, 23, 40, 49, 51, 53, and 55 and the photographs of the paintings on pp. 10, 50, 70, 73, 76-77, 78-79, 80, 97, 99, 100, 102, 103, 105, 106, 107, 110-111, 112-113, 124, 125, 129, 130, and 133 are by Scott Hyde. The photographs on pp. 20, 21, 22, 70, 98, 104, and 116 and the photographs of the paintings on pp. 65, 74-75, 82, 83, 84-85, 86, 99, 126, 127, 128, 138, 139, and 140-141 are by Mario Cooper.

INDEX